INTRODUCTION TO Oil painting

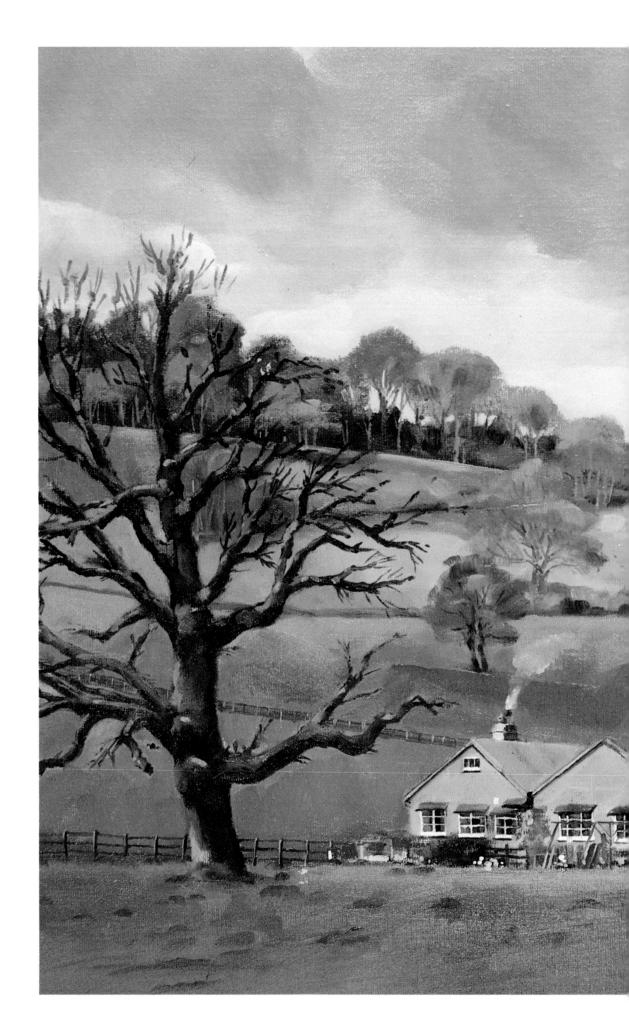

Winter Landscape by Ron Brown, which was painted from life.

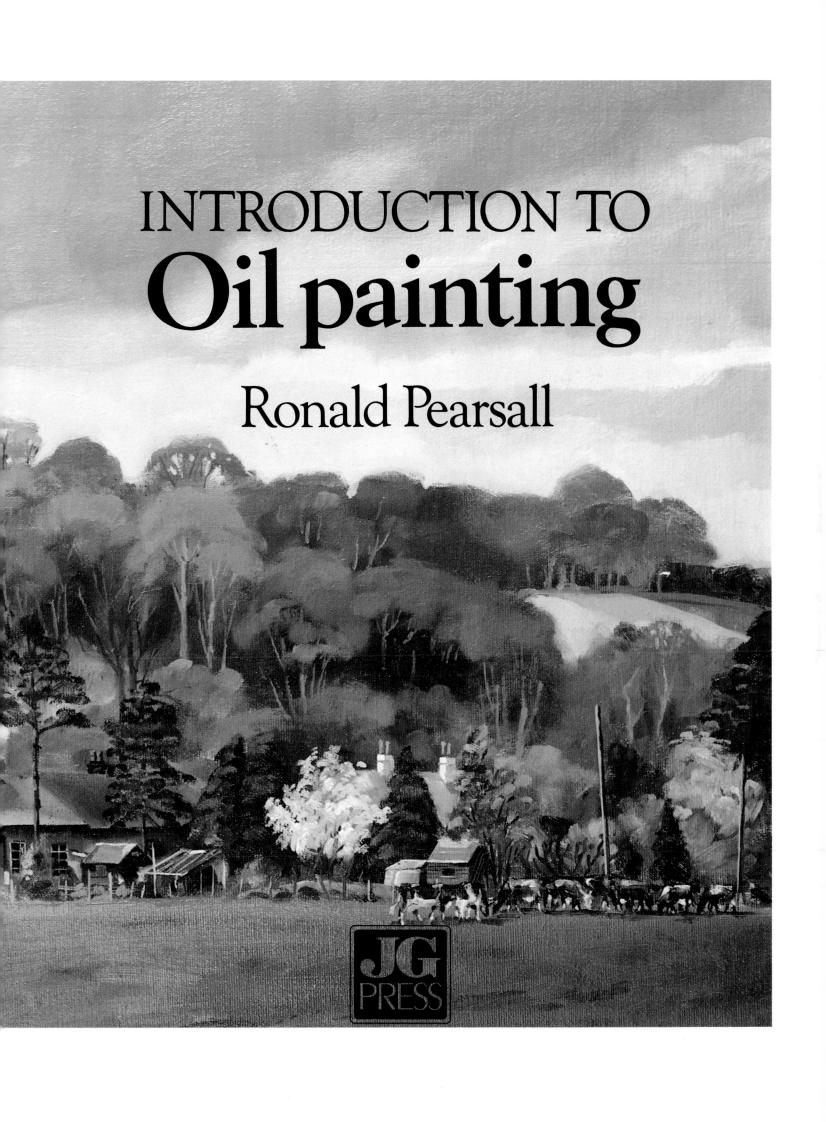

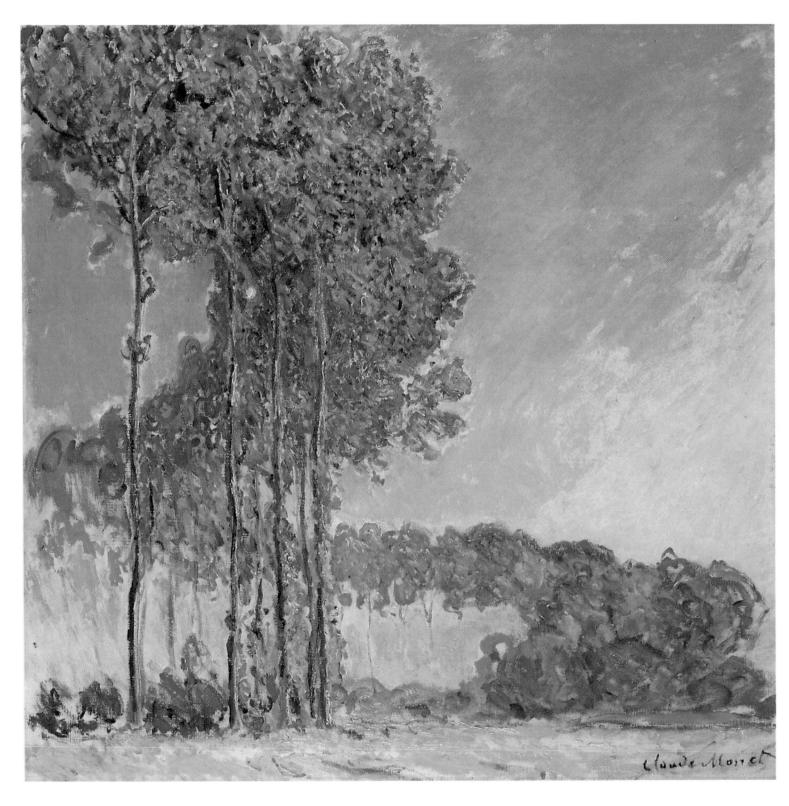

Published in the USA 1995 by JG Press Distributed by World Publications, Inc.

The JG Press imprint is a trademark of JG Press, Inc. 455 Somerset Avenue North Dighton, MA 02764

ISBN 1-57215-085-8

Copyright © 1990, 1993, 1994, 1995, Regency House Publishing Limited.

All rights reserved. No part of this publication may be reproduced, stored in a retrieval system, or transmitted, in any form or by any means, electronic, mechanical, photocopying or otherwise, without permission in writing from the publisher.

Printed in China.

Poplars by Claude Monet. In this dramatic composition, the poplars follow the curve of the river bank, swing into the centre of the picture and back to the left and then down and away to the right. Cropping heightens the sense of rhythm and space.

CONTENTS

Introduction	11
What Are Oil Paints?	12
What Materials Are Needed?	12
How Do I Start?	23
Perspective and Drawing	36
Landscapes	42
Sea pictures	52
Life drawing and portraits	56
Still life and flowers	61
Advanced Techniques	7 3
Colour schemes	91
Framing	93

Introduction

For those who like a challenge there is no substitute for painting in oils. Many people believe that it needs three tons of equipment to set up. This is not so. All you need are a few brushes, paints, something on which to spread the paints for mixing, and something to paint on.

Oils have a quality of their own. The paint can be thick and luscious – some painters build up their paint until it is an inch thick – or it can be hardly more than a stain. There is nothing you cannot do with oils. You don't have to stand at a huge easel and splash about. Some of the best artists have done their work on tiny pieces of card three or four inches across.

There is no one best way of painting oil pictures. This book will name some of the methods, but you may very well evolve your own. Perhaps you like atmospheric landscapes but, when faced with thick pigment oozing from a tube, you wonder how you can do them. However much you try, you find that the paint is being built up on the picture surface. What do you do?

This was a problem faced more than sixty years ago. So what did an eminent art teacher do? He gently placed a sheet of tissue paper on the wet painting. This absorbed the surplus paint and left a misty film. Just what he wanted. And perhaps a trick that you can use.

Adventure, enjoyment, challenge – painting in oils has them all. Just take the first step.

Section of the still life study

WHAT ARE OIL PAINTS?

Most pigments are multi-purpose; oil paints are pigments blended with oil. They are put on a surface with a brush or a palette knife, either neat from the tube or mixed with something to make the paint run nicely. There is always learned dispute as to which is more difficult, oil or watercolour, and there is no answer. Neither is very difficult if you do not panic. Mistakes are easier to take out in oils, and you can use a canvas over and over again.

WHAT MATERIALS ARE NEEDED?

Paints These come in tubes, and there is an immense range. So-called 'students' colours are now labelled differently, and are much cheaper than 'artists' colours. Buying expensive ranges offers no real advantage as most paints will outlast you and your children. Until the last century artists made their own pigments from powdered colours, and as this was often a hitor-miss system, especially when the artist was drunk, some of these hand-made colours were so fugitive that they could disappear from the canvas within a few years. Buy big tubes rather than little tubes; if you take the trouble to keep the top on, the paint will stay moist for years and years. I use paints which I bought in the 1950s and they are as good as new. Tubes are always well labelled, and these labels are marked with asterisks to indicate the degree of permanence. This is not very important. To all intents and purposes the colours will stay the same.

However, if you are concerned about the lasting properties of certain pigments, here is a run-down by R. Myerscough-Walker, A.R.I.B.A., who studied the question:

Lead whites: good in oils, not so good in water-colour. Avoid using with vermilion, pale madders, or cadmiums. When Myerscough-Walker was writing it was not realized how dangerous lead-based paints were and, although this danger is minimal to adults who are not going to eat paint or inhale any fumes, there are so many substitutes for lead white that it can safely be regarded as an unnecessary colour.

Zinc and Chinese white: good in watercolour or tempera, liable to crack in oil.

Titanium white: then a new colour, now known to be reliable.

Cadmiums: not to be mixed with lead white or emerald green.

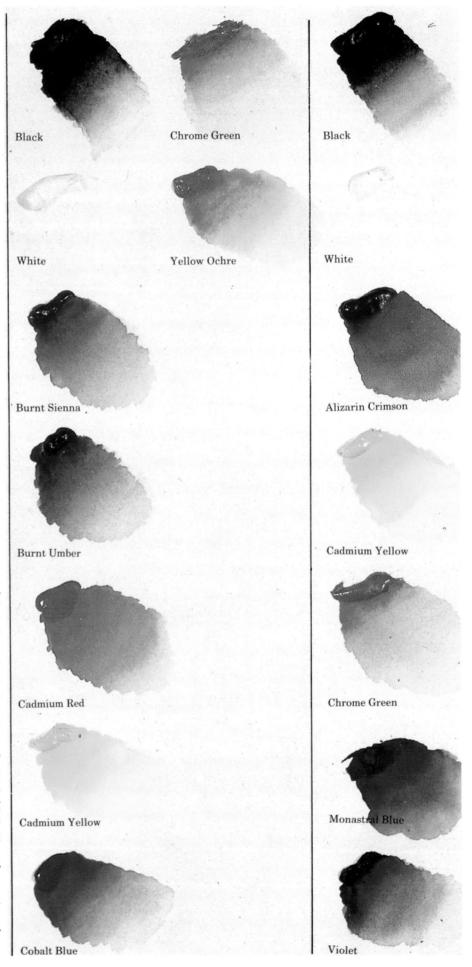

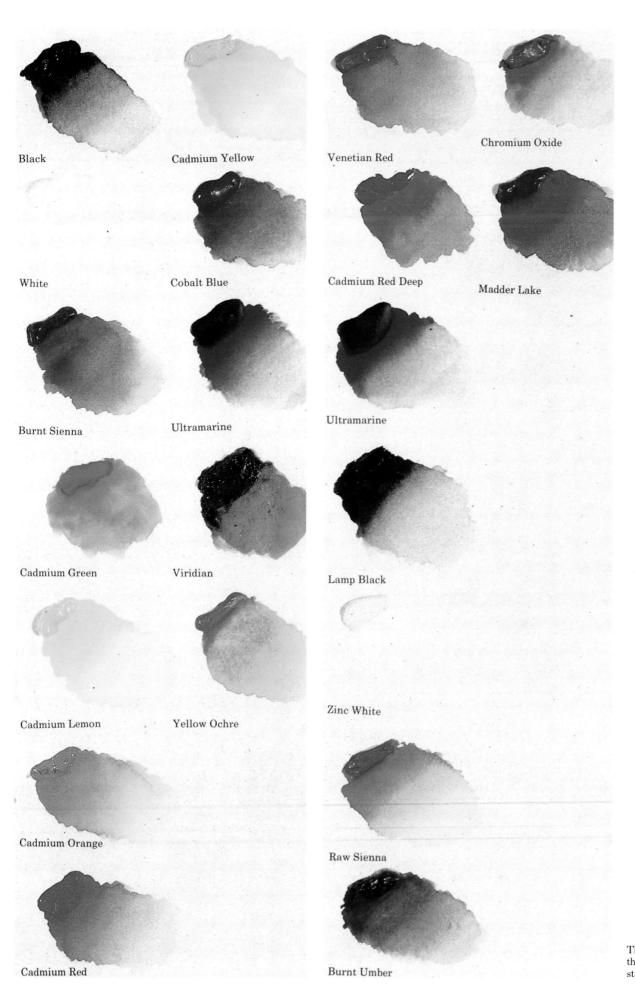

The basic selection of colours that you will need when you start to paint in oils.

Chromes: uncertain unless of the best quality. Raw sienna: very dangerous in oils.

Gamboge: not good in oils, fades in water-colours.

Cadmium red: must not be mixed with malachite, emerald green, or Prussian blue.

Vermilion: must not be mixed with lead white or emerald green. Tends to darken.

Spectrum red: good in watercolours, but may stain a superimposed colour in oils.

Alazarins: must not be mixed with ultramarine. Crimson lake: unusable in any medium.

Ultramarine: must not be used in tempera or mixed with emerald green, chrome yellow, alazarins, or lead white.

Cerulean: difficult to use in watercolour.

Prussian blue (associated with Paris blue, Berlin blue, cyanide, and Antwerp blue): fades in light, must not be mixed with vermilion. Indigo: a colour which should be rejected.

Emerald green: brilliant, but should be use alone.

Cobalt green: sensitive to moisture.

Terre verte: has a large oil content which may darken it.

Cobalt violet: will not mix with ochres.

Umbers: tend to darken in oil.

Prussian brown: no good in oils, and not durable in watercolours.

Vandyke brown: can be made from anything, difficult to classify, and may be regarded as dangerous.

All very interesting no doubt, but most of these strictures can be ignored. If you read too much about colour durability and fading you will find yourself devoting all your time to grinding your own colours or catching bugs such as cochineal, used as a colouring agent in food and also for crimson lake.

Mediums and Glosses There are many of these but the most popular is turpentine, which imparts a matt finish and is very good for detailed work. Most other mediums give a slight gloss, and some of those put out by the large manufacturers include varnish as well as linseed oil. These ready-made mediums are very good, and really there is no need to look further. Poppy oil is a slow-drying medium, liquin is a fast dryer. Some painters do not use medium at all, but use the paint straight from the tube. Others use varnish. Ironmongers' turpentine is much cheaper and just as good as the turpentine sold in art shops. If you are sensitive to the smell of turpentine, use white spirit.

Varnish There is no need to use varnish at all, though you will find that if you use a medium other than turpentine the degree of gloss finish

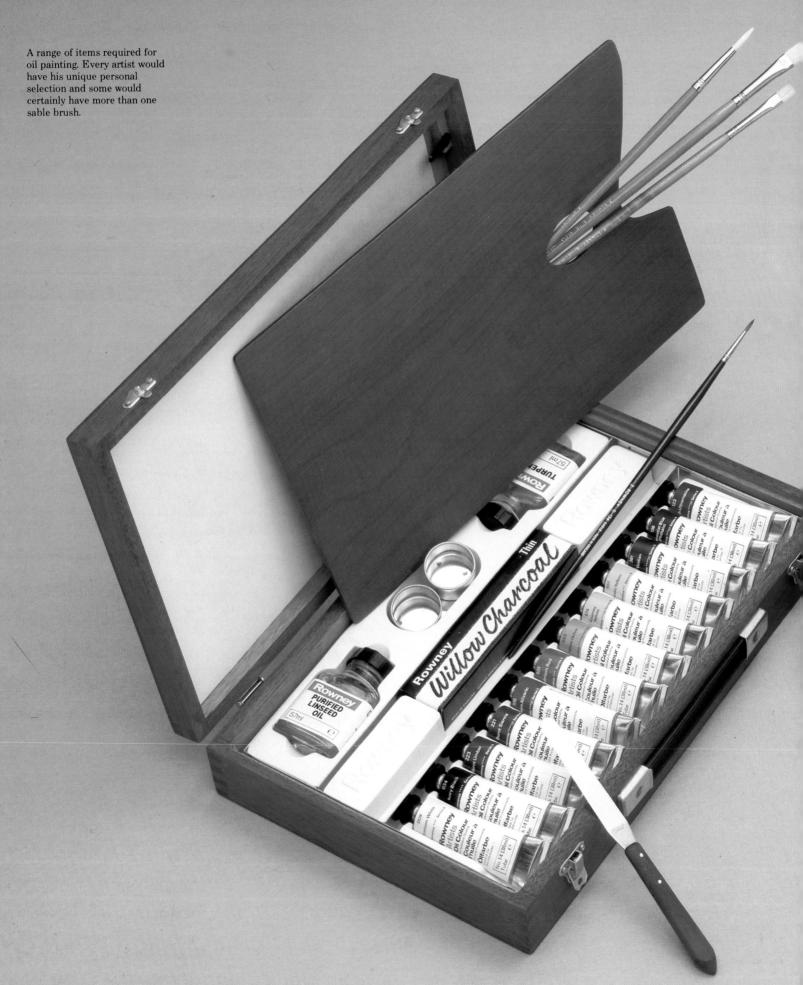

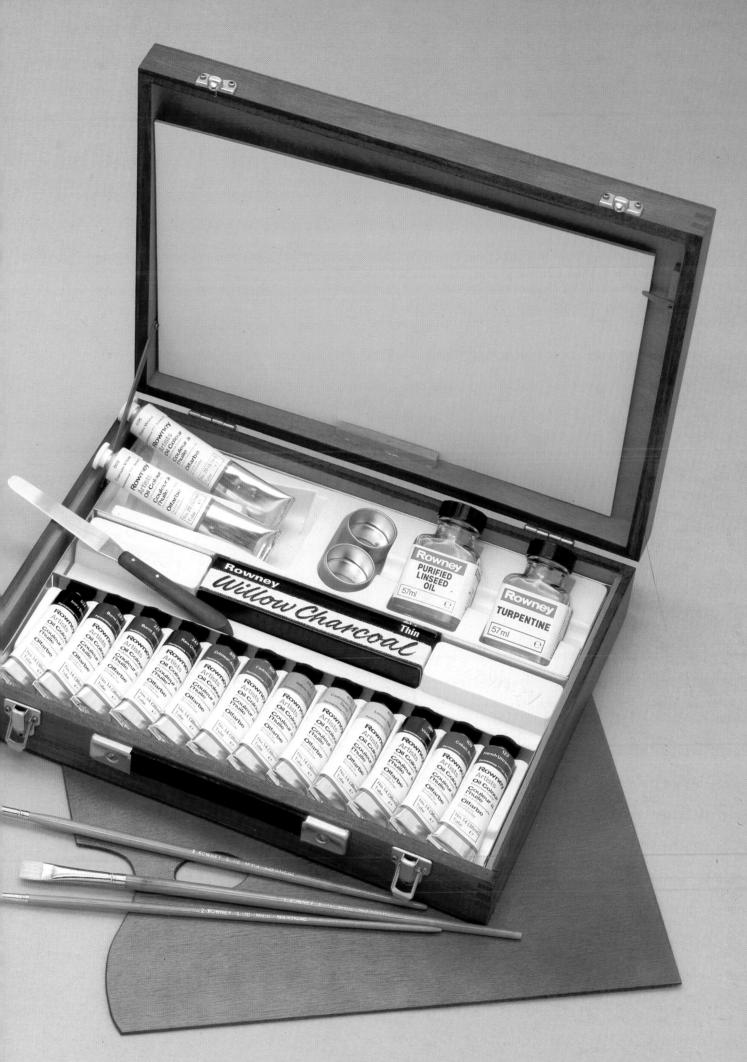

will be variable, and you will want to use a varnish to give an even appearance to the picture surface. Varnishes can be glossy or matt, and a retouching varnish is useful for areas that unaccountably have gone flat. Two coats of thin varnish are better than one coat of thick, and you do not have to wait too long for coats to dry. Some people do not advise varnishing a picture until it has been painted for weeks or months, but you will find that you can do this job as soon as the paint is dry. The thicker the paint layer (or 'impasto') the slower it is to dry, and white is one of the slower dryers, probably because it is applied more thickly for highlights. Many artists find that a flat square-edged soft brush is the best to apply varnish; if you use a bristle, there is a chance of the varnish getting a scratchy look when it dries out.

Brushes Some people prefer a lot of brushes, some a few, and many have their favourite brushes which they have broken in and would not give up for the world. You can use hard brushes or soft brushes; even if you are working on a large scale you can use soft brushes throughout. You have a choice of natural bristle or hair, and nylon, which comes in soft and hard grades and lasts longer than natural products. Artists who work on a small scale or who are keen on detail use small soft brushes; however if you are using sable you can get through two or three (or more) brushes in the course of one picture. After painting, clean your brushes by taking off the surplus paint with tissues or rags and rinsing them in turpentine or white spirit. Every so often, say once a month, wash the brushes using household soap and hot water, drawing the brush handle first through the soap surface and then rinsing under a hot tap. Despite the best care, paint brushes can get clogged, and one of the commercial brush cleaners can come in handy. Paint always clogs at the end of the ferrule, and after a time it becomes hard, even if you scrupulously clean your brushes. Sometimes a proprietary cleaner is essential. After cleaning, brushes should be kept upright in a pot, handles down, with perhaps something like a jam jar for the smaller sable or nylon brushes so that they do not rub against the side of a larger pot.

A basic brush kit consists of: a small, medium and large round bristle; a small, medium and large flat bristle; a small, medium and large round sable (or nylon); a small, medium and large flat sable (or nylon); an ordinary household painting brush for applying a priming coat to a canvas or board; and, an added option, a 'fan' brush, in which the hairs are spread out like a fan, useful for blending. An old shaving

brush can also come in handy for giving textures.

Palette Knives These come in various sizes, and a small, medium and large should be bought. They are used to clean paint from a palette, or to apply paint to a canvas. You can use palette knives to paint an entire picture, or you can merely use them to deposit the paint on the canvas and then employ brushes. Some artists prefer to keep a layer of old paint on the palette knife, others prefer them pristine. The metal of the smaller knives is very thin, and if encrusted paint needs to be removed do it gently as the blades are easily damaged. Always store your knives in a safe place, as otherwise the blades may be accidentally bent.

Palettes Palettes were once made of wood. probably for no better reason than that colours were basically muted and earthy, and wood seemed an appropriate surface. Palettes have a hole in them through which the thumb fits, and now come in plastic, tin, china, aluminium, wood and paper (throwaway palettes). You may not want to use a palette at all, finding it a nuisance, in which case a large plate is just as good. If you are sitting down to do your picture, it is better, as the dished sides prevent the paint from slopping over the top. If you are using a traditional palette, you can get small metal containers which fix to the side of the palette and contain your turpentine or other medium. If you are using a dinner plate, the tops of jars can serve as containers, and be thrown away when the medium begins to coagulate or get dirty. Plastic and tin palettes have circular depressions in them for the paint, but these are often more annoying than useful. If you wish to mix your paints thoroughly, caketins are far more convenient.

Canvases The traditional surface for oil paint is canvas, but although the 'give' of canvas, which is on a stretcher and therefore has no backing, is pleasant, there are many cheaper substitutes for canvas, some of which cost nothing, and can be rescued from the attic, from under the stairs, or from the garage. One of the best surfaces to work on is ordinary cardboard, which merely needs sizing and maybe priming. There is also oil-painting board, oil-painting paper (sold in blocks like sketchpads), wood panels, hardboard (rough or smooth side), and, indeed, almost anything. Oil-painting boards come in a variety of textures, from very smooth to rough. Plywood is a delightful surface to work on, and just needs a coat of size. Much depends on whether you like a rough tooth (grain)or smooth; if you are using stiff brushes you will need a surface with a tooth.

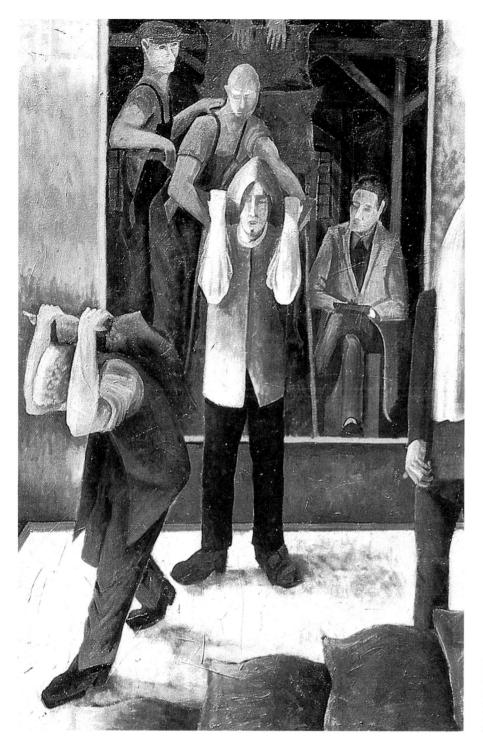

Detail of one of the heads in the picture, treated in a way reminiscent of Cézanne's portrayal of apples.

Newcomers should not feel that they are bound to paint in any prescribed manner but should bring a fresh eye to unusual subjects, as shown here. This can result in striking and novel pictures.

Below: A selection of palette knives of various shapes and sizes.

Easel Even if you prefer to work at a table with the canvas or board horizontal, an easel is very handy, if only as somewhere to prop up a picture to see how it is progressing. If you are working broadly or on a large scale, an easel is essential — or at least an easel-type object. A child's blackboard makes a substitute. Professional artists' easels can be huge contraptions, and a smaller travelling easel will serve most of us well enough.

Drawing Board If you use traditional canvases or canvas board you may not need a drawing board, but if you use oil-painting paper you will. Oil-painting paper is sold in sheets or in a block, but although the block has a thick cardboard backing it is often more convenient to take off each sheet as it is needed. When fixing oil-painting paper or anything which needs to be pinned to the drawing board, first cover the drawing board with a pad of newspaper. This provides a perfect working surface, and also the newspaper is very handy for trying your paint on, to see if you have the right colour, and for getting rid of any surplus medium on your brush. If you work fast and want to get the colours on right away, this is much more convenient than looking around for a piece of paper.

As you get into oil painting there are extra bits and pieces which you will want to add to your basic equipment, and many of these you will discover for yourself. A piece of sponge is one of these accessories. You may wonder why, as sponges naturally go with water, and oil clogs them. Sponges have as a matter of fact been used in painting for some considerable time, to give texture to paint already applied with a brush, and as a painting instrument. We have all seen those ready-made Victorian landscapes with a lake, trees, a bright blue sky, and a yacht in the water. The trees seem to be spattered in, with tiny globules of pigment; the leaves were put in with a piece of sponge and, although flashy, these trees can look very effective from a distance. These pictures, now in such demand by interior decorators, were hack work for the lower end of the market, and were turned out in less than half an hour to a simple formula. For newcomers to oil painting who want to get an easy effect – and no harm in that – a good look at some of these pictures can be helpful. The Victorian painters used natural sponges, because there were no synthetic substitues, but household and car sponges, at a fraction of the cost, serve almost as well if the sharp corners are cut off with a pair of scissors so that you have an irregularly shaped object. For sponge painting on a small scale, cut off a portion of sponge and hold it in a strong paperclip.

Another unlikely accessory is tissue paper. not household tissues which have a dimpled appearance, but ordinary tissue paper as used to wrap up articles in shops. This is to remove the surplus oil and paint off a painting while they are still wet, and it is a trick much employed by British painters of the earlier part of this century. It adds subtlety and atmosphere, and is placed over the moist painting and gently pressed, being taken up when you think that it has absorbed sufficient paint. It is known as 'tonking' after Professor Tonks, a teacher at the Slade School, who pioneered this extremely effective dodge. If you feel that your colouring is too strong and you have not succeeded in getting the picture to hang together, tonking is recommended – and if you find you do not like the effect you can always put the paint back on with a brush.

Sometimes you need a starting-off point for a painting. A few ambiguous dabs of a paint-soaked sponge can do this on the pictures-in-a-fire principle, but tissue paper from a successfully tonked picture can also do this, leaving enigmatic traces of paint on the new surface, ready to spark off the imagination. A surprising number of painters in the past, including Turner, have used random touches of paint to help them on their way, and oil paints, with their richness and variety, are ideal for adven-

ture and experiment. If it fails, all you do is to get a cloth soaked in turpentine and wipe it all off. It is a method well worth trying.

There is no doubt about it, oil paints can be very messy, and a painter's smock is not a quaint garment but very functional. Paint has a habit of dripping down the brush and getting on to the hands, and thus on to clothes, and it is always a good idea to be well provided with household tissues and lots of rag, to clean up the handles of brushes, to wipe surplus paint from the business end of brushes, to clear unwanted areas of paint off a canvas, and to wipe a palette clean when you feel that it has got altogether too congested.

Other items you may need are dividers, to get distances right between various sections of the picture, and a *mahlstick*. This is a wooden rod, often in three telescopic sections fitted together with brass ferrules, with a rounded tip. The stick is for resting your hand on while you are doing fine detailed work, the rounded end rests on the canvas or support, the right hand holds the brush resting on the stick itself, and the left hand holds its far end. A length of ordinary garden cane is a decent substitute for a mahlstick. Cotton buds come in very handy for removing surplus paint off a canvas, tidying up areas, or distributing paint more evenly on the canvas. It is sometimes easier to do this

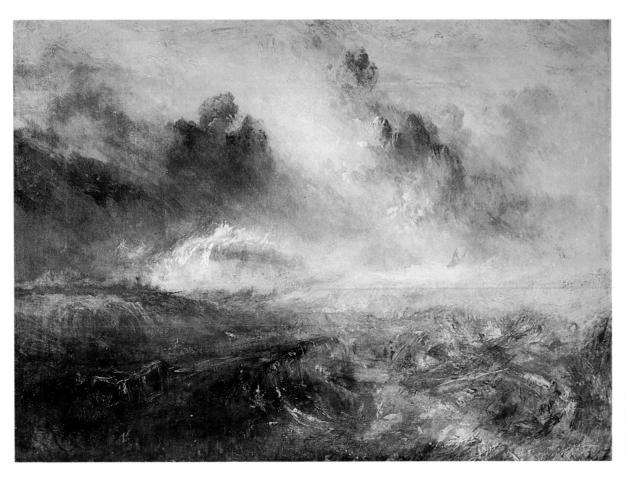

Rough Sea with Wreckage by J. M. W. Turner: A good example of a free and random approach to painting, showing how you can build up detail as you go along.

A delightfully free oil painting. If you happen to be painting in a group with others, take the opportunity to paint your colleagues at their work and they can do the same with you. It is a good idea when starting off to indicate quickly your main areas of colour with paint well diluted with turpentine.

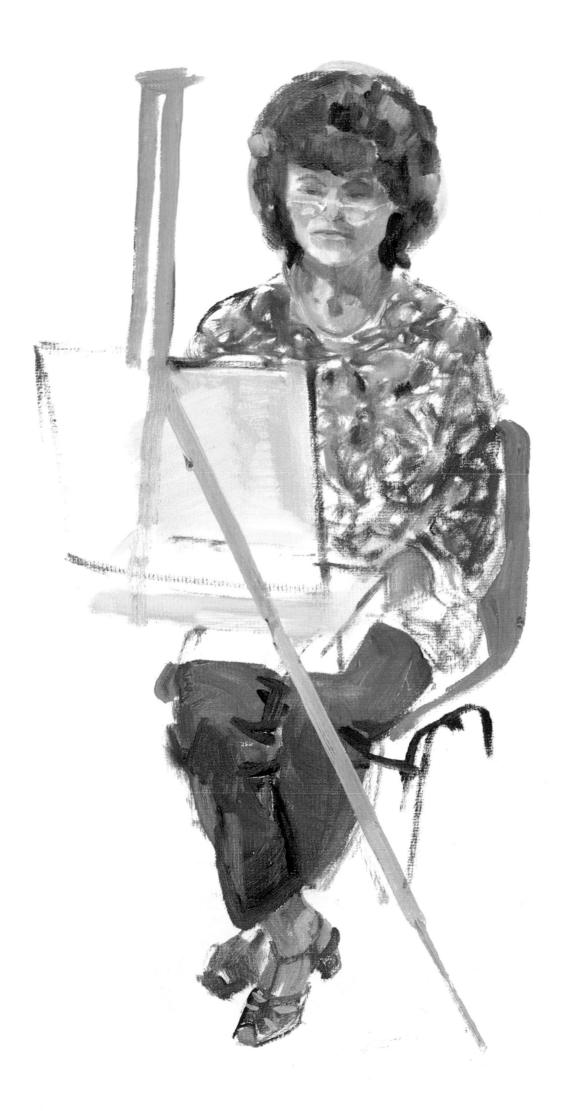

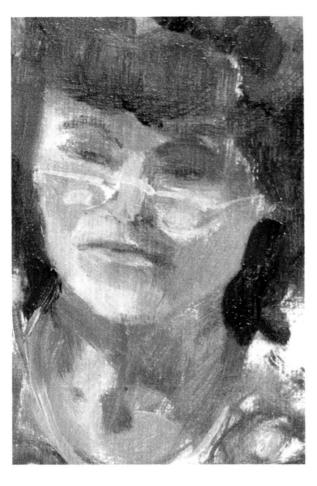

with a cotton bud than a brush.

In addition there are the various items needed when setting down the outlines of an oil painting. Almost anything has been used for this purpose, with the favourite possibly charcoal. Pencils, pens, felt pens, ball-point pens, pastel, can all be pressed into service.

There is one piece of equipment which you will have to make yourself (if there is one on the market few have seen it). This is an aid to help you draw a straight line. The answer is to get a straight edge, preferably wood, and nail or glue together two blocks of wood on it, one at each end, far enough apart to reach dry canvas or, if using oil-painting paper, the drawing board. These blocks should not be more than half an inch high; if they are, the brush will be difficult to control, and if the blocks are not high enough the hairs of the brush will rub against the straight edge, thus damaging them. This do-ityourself instrument can be very useful, not only in oil painting, but in acrylics and watercolour. Drawing a straight line freehand is *not* easy, and almost on the level of difficulty of drawing a perfect circle. If you are doing sea pictures and the ropes and tackle need to be taut and straight, this ruler-on-stilts can be indispensable.

Left: Detail of a head showing simple glazes. When sketching in at the early stage, try to develop a simple shorthand technique, such as in the detail of the feet (below)

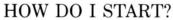

Some mediums such as pastels and watercolours can be taken up as and when it suits you, for as short a time as you want, but if you are going to paint in oils you do need a little preparation in order to avoid getting in a mess. If you are working on the flat, use pads of newspapers to cover the surfaces. These not only absorb blobs of paint or splashes of turpentine, but prevent them from going onto sensitive surfaces. Go through your brushes and check them to see that they are reasonably clean, and pick out the ones you are likely to use. Squeeze out the colours on your palette. Some artists have a set order, light to dark (white, yellow, orange, blue, green, brown, black), but others put them down in any order. If you like a specific range of colours (see Colour Schemes p. 91) you will no doubt get into the habit of placing the colours in some kind of order, but many painters put out the colours they feel they want to use in this particular picture.

There is no need to clean the palette after each painting session. When there is old paint on the palette, often in a mix, it can be used to evolve new colour blends. It is a question of personality. Some artists like to start with a pristine palette, and traces of previous paint

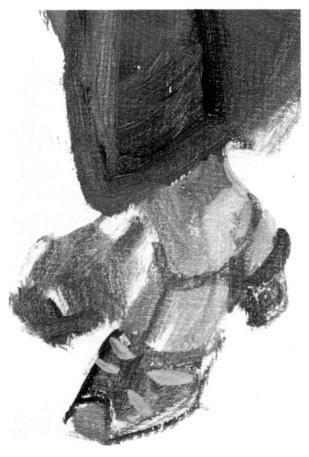

are a personal affront. If you are of this temperament it is worth while using paper throwaway palettes. Sometimes there comes a time when even the most reluctant palette-cleaner finds that the palette is completely clogged up. In this case, buy a strong household paint stripper and clear the old paint completely. Although oil paint takes a considerable time to dry out, it will acquire a thin shell after three or four days. This can be taken off by using the tip of a palette knife.

Mediums, especially the ready-made ones with an element of varnish, also film over after a time, and this crust can again be picked off with a palette knife. Turpentine evaporates slowly, therefore it is advisable to keep it in a jar with a screw-on lid. But do not be niggardly about turpentine; it is cheap, and if you are covering a large area you will find it convenient to use it from a small bowl, preferably a pottery and *not* plastic one. Some plastics melt when exposed to strong liquids.

If you are using an easel, make certain that it is at a convenient height and angle, and that the legs will not splay out as soon as you apply pressure to the canvas or working surface. If you prefer, sit down to the easel. Wind-up office chairs are better than ordinary dining or kitchen chairs, and a chair with arms can be infuriating. Make certain there is newspaper on the floor, or at least something which can be kept clean, and not carpet.

Keep the equipment you need within easy reach, and always have plenty of rags and tissues at hand. When you are setting up remember that if you are using natural light, and do not have a north window (where the light is constant), this will change in the course of a painting session.

'I have my equipment ready, and am working flat on a table. I have some smooth oilpainting paper. I have never touched a paint brush since I left school, I am by nature a meticulous sort of person, and I would like to do something simple and reasonably "like" and which does not look like something the dog walked over.'

One of the easiest kinds of picture to paint is a simple seascape. No complicated shadows are involved, and for the more ambitious there are extra options to make the picture more interesting.

Place the board vertically, and two-thirds of the way down draw a straight line across, using measurements and a ruler. This is your skyline. This is the only preliminary work you will need to do. Mix a blue with white, not too much blue, plenty of white, and do not mix it too thoroughly,

Preparation for a simple seascape.

Step 1: Draw a straight line across the canvas two-thirds of the way down. This is your horizon line.

Step 2: Mix a blue with white and begin to apply the paint with a medium bristle brush, the darker blue at the top graduating to paler blue on the horizon.

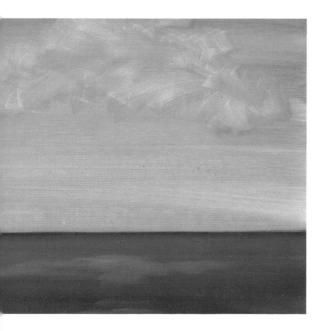

Step 3: Mix the sea colour with blue and green and paint the bottom one-third of the canvas with this combination. Draw in the clouds using a little white mixed with a trace of yellow ochre.

and add a splash of turpentine so that the colour runs nicely. Begin applying the paint with a medium bristle from the top down, darker blue at the top, near white at the bottom, where the skyline comes. *Option:* Go over this area with a medium soft brush, fusing in the blue and the white, and getting a more enamel-like surface. *Further Option:* Draw in clouds, using a little white maybe mixed with a trace of raw sienna or yellow ochre. If you wish to have some shadow at the bottom of the clouds, use a very small amount of black or vandyke brown.

Mix a sea colour. Seas vary enormously, and you can select your own blend. Blue plus green is the traditional colour, but you can add browns and yellows. Paint the bottom third of the board with this mix, making certain that the paint at the top meets the sky perfectly horizontally. Use the side of a flat brush to make the meeting of the two colours clean. Make the bottom of the picture somewhat darker than the skyline area by adding a brown or a touch of black. Option: Go over this area with a medium soft brush.. Further Option: Suggest waves by touches of white. Beneath the white add darker colours (blue plus brown, or green plus brown) to indicate shadow. If you have difficulty indicating waves in this way, look at photographs of pictures with waves in them.

Put in some land feature on the horizon. Burnt sienna with a touch of blue is suitable. This feature can be quite small, and as the sky is light you can overpaint. If the sky paint is too rich and not dry, take out the area you want to cover with a small palette knife, and then paint over. *Option:* Indicate some kind of shadow on the land, by either applying a touch of white, or a touch of darker colour.

Paint a ship somewhere in the middle of the sea area, not too far from the horizon (otherwise you are looking down on the ship which makes the shape less comprehensible). You are painting the shape of a ship, and you have the choice of two simple forms, a ship with a funnel or funnels, and a ship with sails. Do not be too ambitious. The ship merely serves as an accent. You may care to wait for the sea to dry, but otherwise, with the point of a divider or similar pointed object such as the wrong end of a paint brush, pick out in the wet paint the outline of your ship, removing the paint enclosed in your outline with a small palette knife. Then fill in, using black. Option: Add highlights on the ship using the smallest soft brush with white. Highlights can occur on the funnel, on the superstructure, or on the deck where the black meets the sea. On sails, the highlights can occur on one side or on the hull. Further Option: Add a trace of white where the bottom of the ship

Right: The final seascape.
Step 4: Suggest a hint of land
on the horizon with a touch of
burnt sienna and blue and
then place a boat in the centre
of the sea area, with some
birds for added interest.

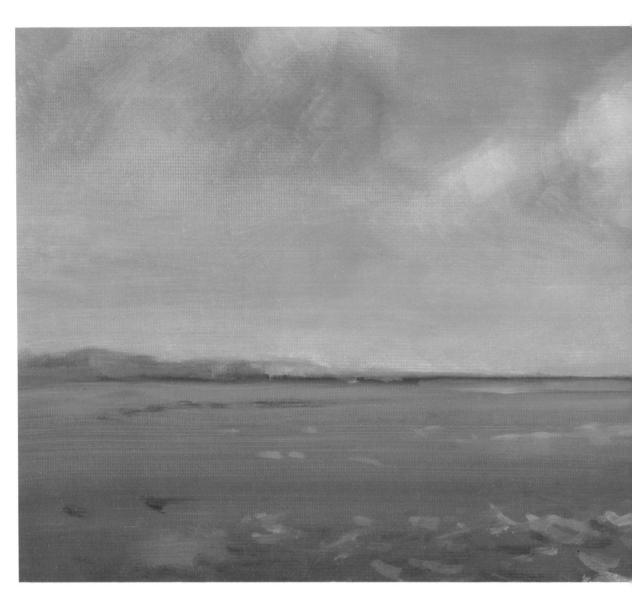

meets the waves. This white can be irregular, indicating the action of waves. Add birds at will (flat V-shapes in white against the sea, or black or grey against the sky).

Then you will have a simple picture. As such it will look neat and unpretentious. You can fill it in further if you wish, by adding foreground interest (a hemisphere in red, with the red darkened where it meets the sea - this is the traditional marine picture filler, a buoy). While the paint is still wet, you can modify the sky, by sunsetting it (a whisper of crimson in the blue/ white), or adding a trace of yellow. You can make the clouds more specific. You can add a tiny ship on the horizon, using your smallest soft pointed brush, grading the colour down so that it is just visible against the sky. When the picture is dry, you can glaze it, putting on an overall coat of thin paint liberally diluted with either turpentine or medium. You can use almost any colour to transform the appearance of the picture, and you can apply further glazes as you wish. You can apply part glazes, covering

one part of the picture. You may wish to darken the foreground with a glaze of dark brown or black. You may wish to brighten up an area of the sea with a glaze of white. When the glazes are dry, you can varnish if you wish (some pictures look better unvarnished and matt).

'I would like to try something a little more demanding, using traditional techniques.'

Try a landscape with hills in the background, a middle distance of trees, and a foreground of water. Mix your sky, blue and white, and keeping the top of the painting a darker tint apply the paint with a loaded bristle brush. If you have any sky colour left, add some red, and remix for the hills, laying in the colour with broad strokes, putting in your light and shade (darkening the mix with more blue or brown or lightening it with white or yellow). You can pick either side of the hills for your shadow area.

The trees in the middle distance are not too precise, yet not vague, and can be painted in either a mixed green (blue plus yellow) or a

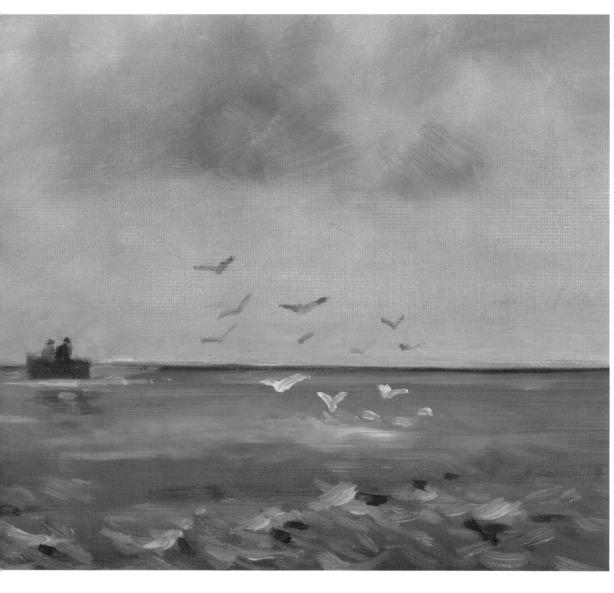

Below: It is essential to remember from which side of the sky the light is coming. Try to vary the cloud formations in each picture, as an interesting sky will enhance any picture.

tube green such as chromium green with maybe a touch of Prussian blue. The bank on the far side of the water can be put in with yellow ochre with a dash of a green or blue. The water is put in with smooth horizontal strokes, blue, darkish green, with an added medium brown such as burnt sienna to cool the mix, and ripples added in white, using either the small bristle or the small soft brush. The reflections of the trees and the hills in the water are always vertically beneath the objects, a similar colour but darker. You can break the outlines of the reflection by ripple.

The overall impression of the foreground can be thick and warm, using the bristle brush fully loaded with paint. You can either thoroughly blend your colours (green and red), or can apply them wet on wet individually, adding maybe yellow ochre. Dabbing the colour on gives the impression of rough ground, and by adding shadows in the foreground you can specify the nature of the ground (grass, stones, add brown or black to your mix for shadows).

A three-step method of building up a lake painting, with the finished picture and list of colours used.

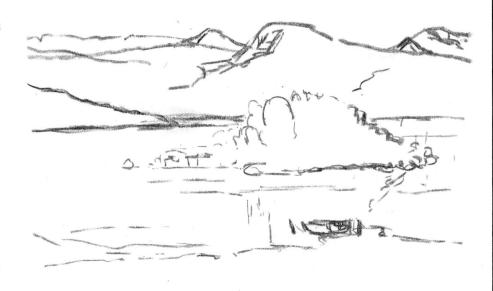

Step 1: Quickly sketch in the scene, using charcoal or a carpenter's pencil.

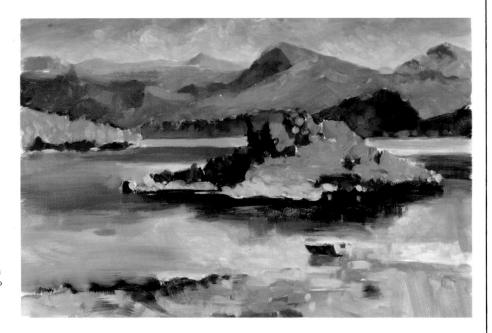

Step 2: Using a one-inch flat brush, sketch in loosely the colours, which are mixed with plenty of turpentine. Make no attempt at this stage to draw in any detail.

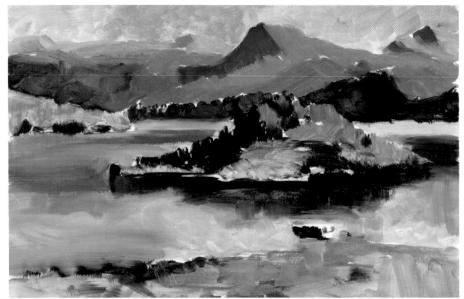

Colors used (top to bottom): Titanium white Yellow ochre Chrome green Sap green Crimson Prussian blue

Step 3: Using a long, size three filbert brush start to build up the thicker layers of oil paint. Subtly indicate the cloud formations to draw the eye into the centre of the picture.

If the final picture seems tame, add further hills behind those already there in a lighter tone with more emphasis on the blue, or in the middle distance add a touch or two of pure colour, suggesting the presence of cottages or buildings, or even figures. You can refine the whole picture by making the focal point the far bank, picking out the trees with more detail, and adding fairly precise figures (remembering to include them in your reflections).

For more subtlety, blur the hill outlines with a flat brush, and then blur the foreground, so that only the middle distance is in any kind of focus. When you are blurring distances or foregrounds, it is better to do it in light horizontal sweeps, and remember to amend any clouds you may have put in.

In many pictures pure white clouds can freeze a picture, and yellow ochre and a hint of red mixed in with the white can provide a warmer, less bracing, touch. Clouds are always sharper in outline at the top than the bottom, and also lighter. The sky need not necessarily be blue; yellow, pink, and even purple can be used for dramatic effect. A glaring sun in the sky is difficult to pull off, but worth trying.

'I would like to do a simple still life in a rather different technique.'

Bottles and jugs, with the odd apple or orange, can be used almost at a moment's notice. Place a thin wash of colour over the canvas to establish a general tone, and then roughly draw in the objects in charcoal. Then take a flat soft brush, half-inch or so, and using horizontal strokes all the time put in the shapes of the objects in their natural colour, or slightly subdued natural colour. Put in your background with rather thicker paint, not worrying if you are overlapping your objects, and then put in the darks of your principal items. You keep the same size brush throughout, though of course you can use two or three the same size if you wish to reserve one of the brushes for the lighter tones.

On top of the darks you put your half-tones, keeping the same *texture* of paint, and you can now use the brush vertically or diagonally, but keeping it flat and not overloading it with paint. Apply the highlights in white, still with the flat brush, but keep the whole composition muted. To increase the atmosphere you can gently add other colours – not necessarily those 'in life' –

Step 4: At this final stage, work in the overall detail using a smaller filbert brush until the painting appears to be finished. Stop then, before you overwork the subject and spoil it.

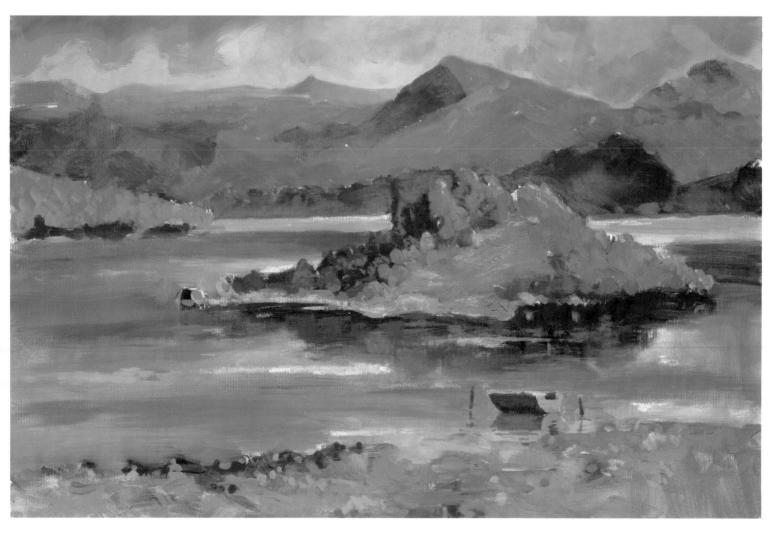

These illustrations, and those on the following pages, demonstrate the progress of a simple still life from the original photograph to the finished painting, showing the intermediate steps.

Composition and eye level are most important when sketching from still life. These sketches show some of the mistakes commonly made by beginners.

Objects are arranged too formally.

The eye level is too low and the objects too centralized.

but these additional colours are blended in to the basic colour. The whole surface of the painting will be regular, but avoid an egg-shell finish and allow the object edges to be a little fuzzy and indistinct.

This square brush technique was brought to a peak of perfection by the Newlyn School of painters who flourished in Cornwall just before the turn of the century, and it became a staple technique for art colleges throughout Britain. The practice of this method encourages sensitivity to tone. It is best practised with turpentine rather than one of the juicier mediums, and pictures painted in this way do not need to be varnished. If you feel that the colours are too strident, you can 'tonk' the pictures, by placing a sheet of tissue over the surface to absorb excess paint and moisture.

With oil paints there is no end to the possibilities and usable techniques, and it is the only medium where errors can be removed by the simple method of wiping them off with a cloth or scraping them off with a palette knife. If you wish to spend a fair amount of time on a painting use the methods employed by the great painters of the past (see chapter on Advanced Techniques). They painted in a series of transparent glazes, laying one on top of the other, building the picture up gradually. Another method is to carry out an underpainting in much diluted paint, staining rather than painting. The underpainting is not concerned with detail, but in establishing the areas of tone, and covering the white of the canvas. Whatever you are doing, it is often - even usually - better to tint the canvas. In an underpainting white is not used, and the dark and light colours are obtained by the amount of turpentine in the wash, and no more than four colours are needed – a blue, a couple of browns, and yellow ochre or raw sienna.

Once the tone of the picture has been set by the underpainting, the overpainting can be as thick as you like. It is often advisable to put the paint on in direct abrupt touches rather than stroking it on, without worrying too much about overlapping adjacent areas. Surplus paint can be scraped off or overpainted. But do not imagine that you have to be rough and ready to make a 'real' oil painting. The worst amateur paintings are these rough and ready paintings, in which the brush strokes come through as if they were made with a rake, and the edges are untidy and wispy, as if the artist was unable to come to grips with the task of getting colours to meet on a canvas.

If you want to work on a tiny scale, do so, but avoid canvas and use cardboard or a smooth surface (not oil-painting paper as that has a marked tooth). Be as precise as you like with your initial design, if necessary using a fine nib (always finer than the sharpest pencil point). Use small soft brushes (00 and 01) throughout, and if you wish make use of a magnifying glass (the type on a heavy stand is the most helpful). It is an odd fact that by using a magnifying glass, the hand seems to acquire the ability to carry out the most minute work.

All techniques can be used in miniature painting. The flat brush method can be employed by working with the smallest flat brushes. You can use successive glazes, and you can underpaint. There are some people who find it difficult to paint on a small scale, and if you are talented in this respect make the most of it. There is nothing that takes the eye more than an exquisite miniature.

The usual method of oil painting is to paint in the darks first, and superimpose the half-tones and the lights, and many painters in watercolours also do this, though you will find many writers on watercolour painting not keen on this idea. By putting in the darks first, you immediately get some idea of the shape the picture is taking, and it will give you freedom when you put in the lighter colours, freedom to intrude on the dark areas with your light colours, even mixing in the lights with the darks.

You can apply the paint onto the canvas in many ways. You can take the paint with your palette knife, spread it on the appropriate part of the canvas, and then get to work with your brush. You can load the brush with paint from the palette, and mix on the palette with your medium before going to the canvas. You can apply the paint from the palette onto the canvas, and add the medium to the paint already down. In this case, you will lay the paint down fairly roughly, keeping well within your outlines, only getting your edges in with the arrival of the medium. You can also apply the paint directly from the tube, and indeed some artists use the nozzle of the tube to spread the paint. You have to be very sure of yourself to do this, as it can result in an unholy mess.

If not using brushes at all but only palette knives, be sparing of the medium. You can mix paint on the palette, taking it off with a smooth sweep of the palette knife, or you can squeeze the pure colour on to the palette knife, spread it on the canvas, and do the mixing there. Do not try to do palette-knife work with too little paint, but if you want to work up a rich impasto while economizing on paint you can add wax to the mix, a technique used by van Gogh.

If you are using a palette knife or any method involving thick paint any outline drawing you have made will soon disappear, so do not panic if your guide lines suddenly disappear. You can

Here the composition begins to gain interest.

The complete composition with interesting placement of objects.

A rough sketch for 'abstraction' of shapes of the objects.

Making a still life poses an interesting problem for the oil painter as he can arrange his subject matter as he pleases. The paintings on these two pages show the progression and details painted from life as in the photograph (right).

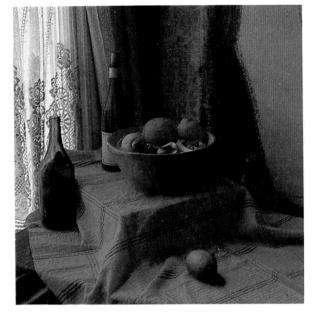

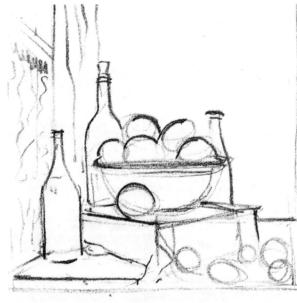

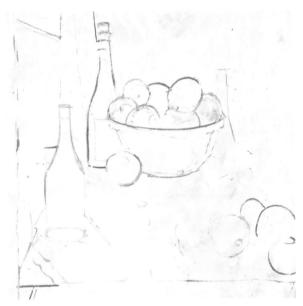

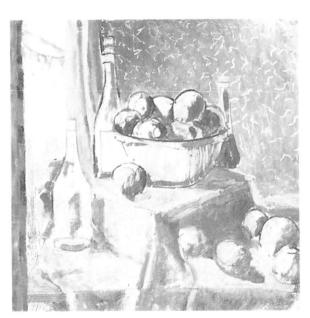

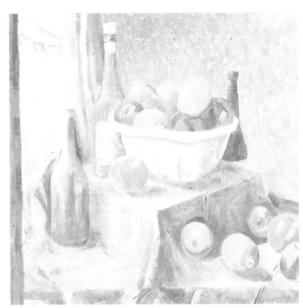

Far right: List of colours used to paint this picture.

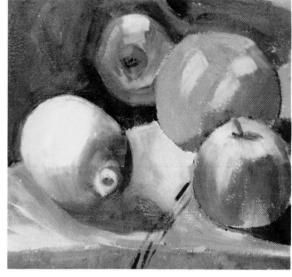

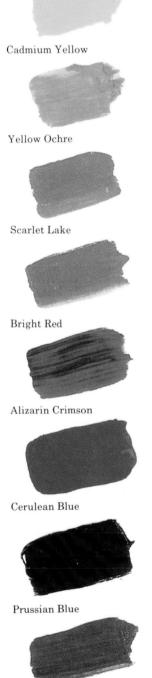

Burnt Sienna

Zinc White

Lemon Yellow

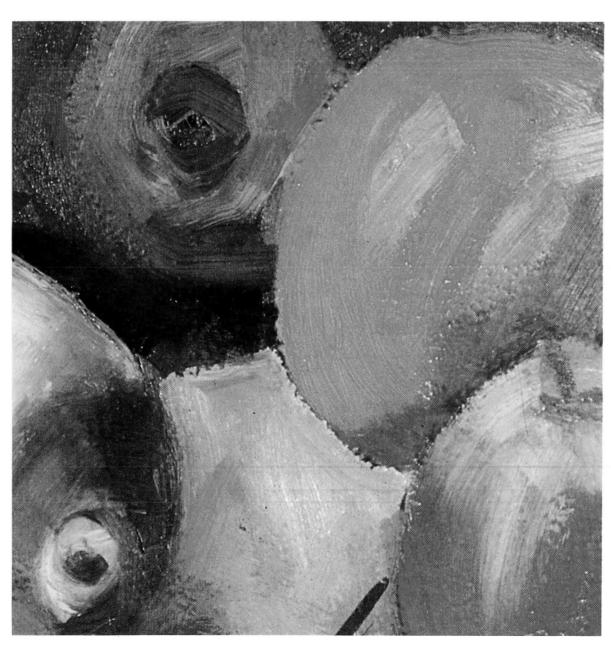

put them back using thin brush strokes, if your paint surface will take them, or you can 'draw' on the paint with the point of a pair of dividers or the wrong end of your brush. Always remember that a painting involves outline and shapes, at least in the initial stages. Adjoining shapes are not sacrosanct; you can 'bite' into them with neighbouring colours. For example, in a landscape one of your trees may seem lifeless and need pepping up with more interesting leafage. There is no necessity to add foliage in foliage colour; you can alter the look of the tree by bringing in sky colour on top of the green, taking out the superfluous green with a small palette knife if the paint is not yet dry.

The versatility of oil paint can never be emphasized enough. There is *nothing* you cannot do with it. You can work over and over again on some passage you do not feel happy about, though in watercolour overworking can show, resulting in a tired picture. Although the Victorian painter Burne-Jones was exceptional in spending five years or more on a single picture, give yourself plenty of time when painting an oil, and if you feel slightly uncertain about the progress of a picture put it to one side for a month or so and then return to it.

The palette knife can be variously used to apply a thin coating of paint or to work up to a rich impasto. It is traditionally used for building up thick layers of paint.

Scumbling. The paint is scrubbed sparingly onto the canvas with a stiff brush.

Glazing. This consists of successive applications of thinned-down paint. Ensure that each coat is dry before applying the next.

Left: A palette knife has been used for this simple still life, using limited colours and mixing the paint directly onto the canvas.

Below: This delightful van Gogh landscape depends a great deal on brush technique for its success.

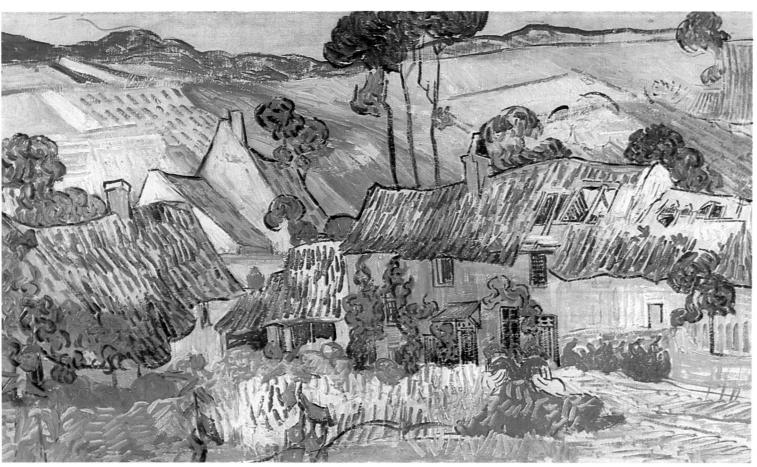

PERSPECTIVE AND DRAWING

Oil painting can be as easy or as difficult as you wish, and you can make a good-looking picture without knowing anything about drawing or perspective. But if you want to do a realistic picture, in which the components are set in space – even if it is a space of your own making – it is advisable to know something about perspective. It does not have to be a lot; you are not going to be asked to do architectural drawings, and nothing about perspective is very complicated.

If you lift your eyes from this page and look around, you will no doubt see objects with flat rectangular surfaces, such as the top of a television set or the top of a table, both below eye level. Even if the top of the table is a perfect rectangle you will see that the two sides appear to move in toward each other. If these lines are extended they will meet. If you bend down slightly, so that the surfaces are only just below eye-level, the converging lines will seem to move toward each other at a sharper angle. This is perspective in action.

Of course all objects in the room will do the same, and if you are going to draw or paint them you will have to be aware of perspective, even if you just make a token gesture toward it to make the picture look right. For perspective is an instrument, nothing more, nothing less.

If you look down a straight road in the direction of the horizon the road appears to narrow, and a person walking along this road seems to get smaller, losing height at the same rate as the road narrows. If there are telegraph poles spaced along the road they will seem to diminish in size until they appear in the distance like matchsticks. If you draw an imaginary line between the bases of the poles and between the tops of the poles you will find that they meet on the horizon. The only time a true horizon is seen is at sea, where the sky meets the water, for the horizon has nothing to do with the skyline. If you were in the Alps the sky-line, where the tops of the mountains meet the sky, would be high above you, and the horizon would be behind the mountains, at eye-level. That is where the horizon always is, at eye-level.

Surfaces on objects above the horizon appear to go down toward the horizon, those below appear to go up. If you look at the roof of a house from any aspect except straight in front you will see it leading down toward eye-level in the distance. The top of the roof will lead down at a sharper angle than the bottom of the roof. If you extend a line following the roof it will reach the horizon at a vanishing point. If there is more than one roof and each is pointing a An exercise in perspective taken from a high viewpoint. Our eye level is about two-thirds down the page and we are looking above the rooftops. But still the church towers way above.

different way, as in a country village built around the village green, you will note that every roof leads to the horizon but each roof has its own vanishing point. There is only one horizon in a scene, but any number of vanishing points. If you stoop, the horizon will change, and the direction of the roofs – or walls, or anything in the view – will tilt further, not significantly but enough to notice. If you look up at a church tower, which you know is square-topped, the angle will be much sharper, and if you did not know better you would say that it was triangular.

Without the use of perspective a painting will be flat; you will be making a pattern on the surface. One part of the painting will be the same distance from the eyes as any other. Once perspective is introduced you achieve solidity and recession, and the objects 'out there' will be displayed in their own kind of space. If you have done a simple picture of a ship at sea you will have used perspective; you have made the ship smaller in relation to waves or anything else in the foreground, and if you have put in a land mass on the horizon you will have placed it behind the ship. And by examining the positions of these objects on the sea there is no doubt about it. As there is only one ship, there are no problems about size and whether it is exactly where it should be on the sea. If more ships are added, and there are more objects relating to each other, you will need to fit them in with more circumspection. If you put a rowing boat in you may put it in front of the bigger vessel, so it is occupying its own space, but it may be in the wrong place; it may be too near the ship and look too large; it may be in the foreground and look like a toy. Using perspective will help to keep different subjects in a picture in proportion.

Still keeping to the marine theme, visualize a picture in which a ship is in the foreground. If the horizon is low, you may not see the top of the deck. If it is high, you may be looking down on the ship, as if you are standing on a cliff above a harbour or on a pier. Suppose you want to add other ships of a similar size to the one in the picture; do you just put them in, hoping for the best, and if they look out of proportion take the paint off and start again? Perhaps, but it is easier to draw a line from the bow of the ship where it meets the water, and a line from the top of the funnel or mast, and extend them to the same point on the horizon. It does not matter where it is. It can be very close to the ship, in which case the angle of the line will be acute, or it can be at the far edge of the canvas or board; it can even be off the canvas, and if you have the vanishing point a long way off the canvas the lines will be almost parallel.

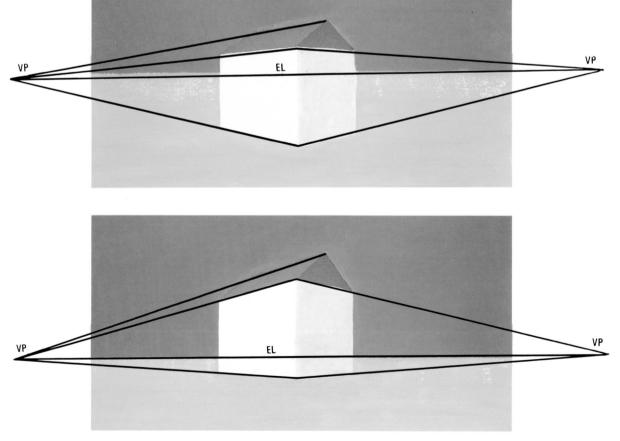

These two sketches of a building illustrate the way in which perspective alters according to the eye level (EL) and viewpoint. When the viewpoint is far away, the angle of perspective is very shallow and the vanishing points (VP) from both walls fall some distance away. As the viewpoint becomes nearer, the vanishing points close up, and the angle of perspective becomes much sharper.

The slot between these converging lines is where you place the vessel. This will give you the correct dimensions anywhere on the canvas - just behind the foreground ship, in the middle distance, near the horizon. Of course, you do not have to place the extra ships within the lines as if they were in a convoy. You can position them across the canvas, if they remain the right size to fit the slot. Naturally you do not want to keep these lines of recession, so if the sea and sky colours are dry, put them in thinly with turpentine and a dull colour, wiping them off when the extra elements have been added. If the background colours are wet, put the lines in with the side of a knife or the point of a pair of compasses or dividers, or the handle end of the brush, biting into the wet paint and smoothing the lines out when you have finished with them.

By using these convergence or perspective lines you can add extras to paintings which need livening up, such as people in a townscape, cows in a landscape, so that they fit in. They are not too big, not too small.

Sometimes perspective can be tinkered with to get dramatic effects, and playing with perspective can have startling results, but if you anticipate doing realistic pictures it cannot be ignored. It is a tool just as much as brushes and paints. All things come into the reckoning, including human figures. If a person extends a clenched fist towards you it will appear enormous, often obliterating the rest of the person. Even objects we do not usually associate with having solidity, such as clouds, are in perspective; some clouds in pictures seem flat and uninteresting. That is because they are put in just as white blotches with perhaps a trace of shading beneath them, and they are placed parallel with the picture plane – in other words, all parts of the cloud are the same distance from the viewer. But they are not. They have shape and body and therefore have to fit in against the sky, to appear to float.

Perspective is not so much a law as a convenience; it is certainly not a hard and fast law like the law of gravity, because there is an exception which goes under the name of accidental vanishing points. Surfaces which are tilted sometimes converge on vanishing points which are above or below eye-level. The best way to see this is to pick up a piece of card and hold it at a slant, watching how the vanishing point changes as you move it around (half-close the eyes when doing this - it is more obvious then). Another example is to look at a road going uphill; the sides will appear to converge at a point above the horizon. If the road is going downhill, the sides will converge below the horizon.

Perspective is a simple matter. If you look at a straight road going towards the horizon it appears to narrow; a person walking along this road appears to get smaller as the distance increases between you and the other person, who loses height at the same rate as the road narrows.

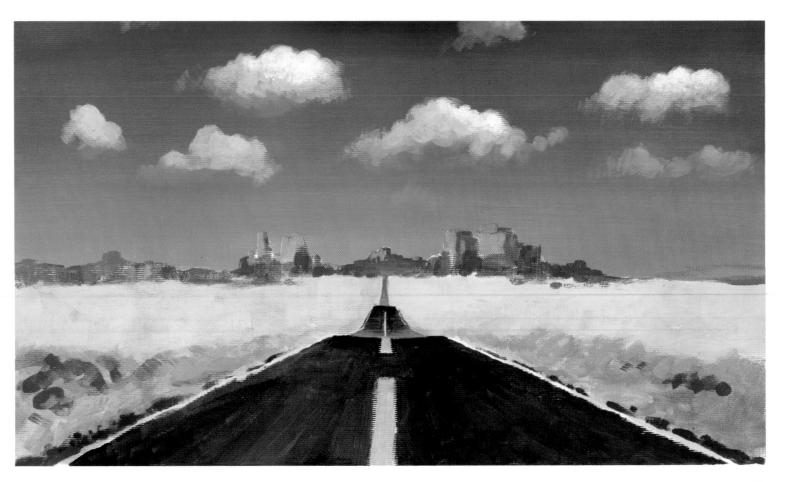

Aerial perspective is to do with atmosphere. Dust and moisture obscure distant objects and views, and the further away something is the less distinct and the lighter in tone it will seem. This is indicated in painting by absence of detail and an all-over bluish tint (this can be done in oils by gently rubbing the background and getting rid of the detail and then applying a light blue glaze over that portion of the picture).

Does perspective work for you? It is a good idea to go out and look at buildings, perhaps taking a pencil with you. How do you start? First of all you put in your horizon. If you are not certain where this lies clench your fist with the thumb uppermost until it is on the level of your eye. This is your horizon. You can put in a few lines setting the scene, lightly, casually, finding your way about, and when you have found a good starting off point you can begin pencilling in with more determination, taking roof lines, the lines of window sills, the tops of doors, the lines which form the division between the walls and the ground, to their vanishing points on the horizon, extending them past the building if you find it easier. If you tackle more than one building you will find that other features intrude with their own particular vanishing points, so that if you are extending all lines of recession you will find quite a busy network of lines appearing on your paper.

There is no need to make a fully fledged drawing; there never is; if there is a window that interests – perhaps there is a fascinating pediment, perhaps you wish to try your hand at putting in the individual panes of glass so that the window does not look like a noughts-and-crosses grid – do this to your satisfaction and then forget the rest of the building. The more you draw the more practised you will be. Even if you are more keen on painting in oils, drawing techniques are a valuable back up, teaching you to observe and assess, and to realize that what you know is not necessarily what you see!

For that is one of the requirements for realistic paintings, to be aware that outlines do not exist 'out there' and are simply a practical means of putting on paper or canvas a division between one tone and another. This division may be sharp - such as the corner of a building where the sun catches one side and the other is in deepest shadow; or it may be so subtle that you can only just detect it, perhaps the merest hollow in the snow. Naturally you may not want to be realistic. It is up to you completely. You can put in an outline and then colour what is inside it, as children do automatically without thinking about it. They are not worried about comparing shapes; if they want to draw a house they make no bones about it - a square, some rectangles on it for doors and windows, and a

As the buildings recede into the distance, they take on a blue-grey tone.

Aerial perspective of New

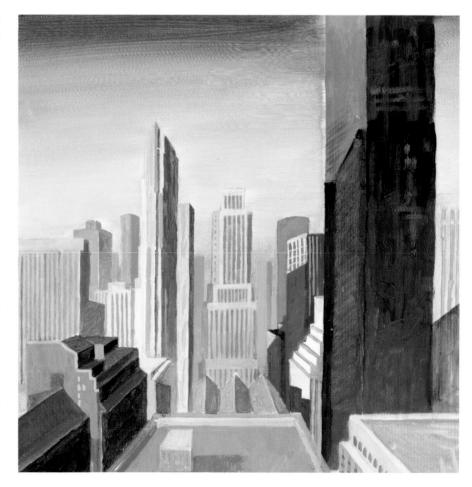

chimney pot puffing forth smoke. Even if they live in high-rise flats and have hardly ever seen a chimney pot, that is the traditional way of doing things – and that's that!

In drawing all you have is outline and tone. In painting, of whatever kind — watercolour, oils, pastels, acrylic — you have colour. Tone is more important than colour, for colour by itself does not give an effect of solidity. You can depict an apple as a red circle; it is just that, a red circle, until you introduce some shading on the side and put some shading on the surface where the apple is resting. It is very easy for novices to be dominated by colour, to let it rule them. But colour must be managed, to perform the role you want it to.

Accurate drawing, whether for its own sake or as a basis for a painting, depends not on manual cleverness but on looking and assessing shapes and the way they relate to each other. All shapes can be drawn accurately, even if they are complex. Some shapes are simple and can be put down with reasonable precision. It can be a barn in the middle of a field.

We do not have to know how the barn was built, and how many rooms it has inside, and whether it is ripe for conversion. All we see is a rectangle with a sloping shape on top (the roof). From certain viewpoints we can see the side of the barn, and observe the shadows, the shadows

on the side of the barn, and the shadows cast onto the ground, which are darker. The rectangle which is the body of the building may be broken up by inner rectangles and squares – the windows and doors – but they may not appear as rectangles even though we know that they are there, for we have spotted the telltale clues – the small horizontal splash of light in the front of the barn (if it is in part shadow) where the overhead sun has picked out the sill of the window leaving the rest in darkness.

The door is recognized by a dark shadow about seven feet up from the ground where the upper part of the door, slightly inset, is shadowed by the brickwork above. This is what you see, and if you are trying to portray the barn as it is this is what you draw or paint. If you think it is not going to make a good picture, go round to the other side of the barn on which the sun is shining. Always draw or paint something which is of interest to you, and if landscapes bore you select other subjects. Landscapes have always been the most popular sort of subject for a variety of reasons. Landscape is there and does not have to be arranged: you can pick any vantage point that suits you; if there are difficult objects to draw you can ignore them or move somewhere else; and landscapes do not move. There are changes of light, but mostly at a fairly leisurely pace.

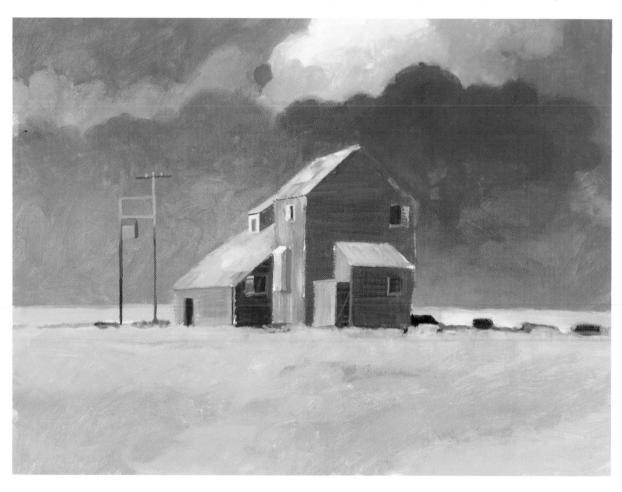

This atmospheric painting of a barn set in a bleak landscape demonstrates all the problems one is likely to meet in both aerial and linear perspective.

Landscapes

How much preliminary work do you put in on a landscape? It depends entirely on you. Are you making notes with the object of finishing the picture at home? Or are you going to complete the picture on the spot?

You may care to put in a few tentative lines, locating the main points of interest. This can be done in pencil, charcoal, the point of a soft brush, or anything. Or you may take a square bristle brush and dab in a few muted shapes, perhaps squarish blobs, establishing where shapes are likely to come, but putting them in a neutral and unobtrusive colour because you may be wrong.

If you are working directly on to canvas one of your first actions is to put something down on the canvas, even if it is merely an all-over tint to take away the blankness of the white, which can be unnerving even to experienced artists. This preliminary tint can help to set the scene. If the sky is brooding and there is a storm threatening use a grey. This grey can even be applied thickly, and the features of the landscape can be inserted while the paint is wet or tacky, either with a brush or with a pointed instrument such as the handle of the brush. If it is bright sunshine and there are promising cornfields, a vellowish tint can be employed which will give a happy feeling to the picture and can be partly used to depict the cornfield.

When you are viewing a landscape you may wonder where the 'edges' of your picture should be. Should you start with something in the middle which will be the main focal point of the picture, and then fill in around it until you fill the whole of the canvas, or should you map it out beforehand? An easy way to decide where the picture will begin and end is to use a home-made viewfinder, a piece of card with a rectangular hole cut out in the middle which you will hold against a likely view, either horizontally or vertically. Not only will you be able to pick out a good composition in which the interest is held in, rather than seeping out at the sides, but by using a viewfinder you will find it easier to relate shapes and tones to each other. Half-closing the eyes helps.

When you start it is advisable to do so at the focal point of your picture (also known as an anchor) and work outwards. But as you have reviewed the scene through the viewfinder you will have a fair idea what will be included and what not. If there is detail it is in the foreground only. Do not imagine it is there in the middle-distance if you cannot see it and are only guessing. If there are trees look to see how the shadows fall, and work out whether these are going to change very much as you work. Notice how groups and clusters of leaves throw

shadows on those below, and that individual leaves are not often seen unless it is winter and they are clinging bleakly to isolated branches. What might seem to be changes of colour in the leaf masses may be changes of tone, though the colour of the underside of the leaf is different from that of the top of the leaf, undetectable unless the leaf is a few feet in front of your eyes.

Trunks should be made to appear solid, by shading, and this shading should be graduated to indicate roundness. The trunks of trees in isolation are not absolutely vertical. Try not to put in a symbolic tree which will be recognized as such but will not fit in realistically. Don't forget the shadows beneath the bottom leaf cluster, which may prevent the trunk being seen, or may just allow glimpses of it through the foliage, and study how the trunk goes into the ground and is not stuck on top of it.

When doing a landscape, all the objects are in it, not on it. Individual blades of grass are in the foreground, not the middle distance, and each blade of grass has its shaded side and is not just a flick of green with a soft pointed brush. Many artists put their grass shadows in first, then insert their blades of grass. Grass further away can best be expressed by shading. Tufts of grass have a shaded side and cast shadows onto the ground just as something more solid, such as a fallen trunk, does. In the middle distance grass can be depicted by graduating the tones as the ground rises and falls. This should be done subtly, altering the basic colour with a series of added tints rather than switching to another colour such as from medium green to a yellow.

Bushes should be observed carefully, for it is very easy to make them appear like cardboard cut-outs. The changes of tone in a bush may not be dramatic, but they are there nevertheless. See how the clumps of leaves at the top of the bush throw shadows on those below, and how the base of the bush, often in deep shadow, can be enlivened by foreground plants and grass which are in the light and stand out against the shade. The tops of bushes fairly near may be around eye-level, so you may be looking down at much of the leafage, looking through clusters of leaves at the shadows below. Hedgerows are splendid accents of interest to have in a landscape and when they are in the distance they can help establish the sizes of other objects such as cottages.

The presence of water in a landscape can bring a picture to life, so look for the clues which tell you – and the person who is going to look at your picture – that it is water and not a path. It is no good painting a bit of light blue with a few tentative reflections in it and hoping

Top right: Step 1: When painting on location it is essential to paint in the entire picture as rapidly as possible, using thinned-down color.

Bottom right: Step 2: Paint can now be built up using a broad brush to give overall tonal value.

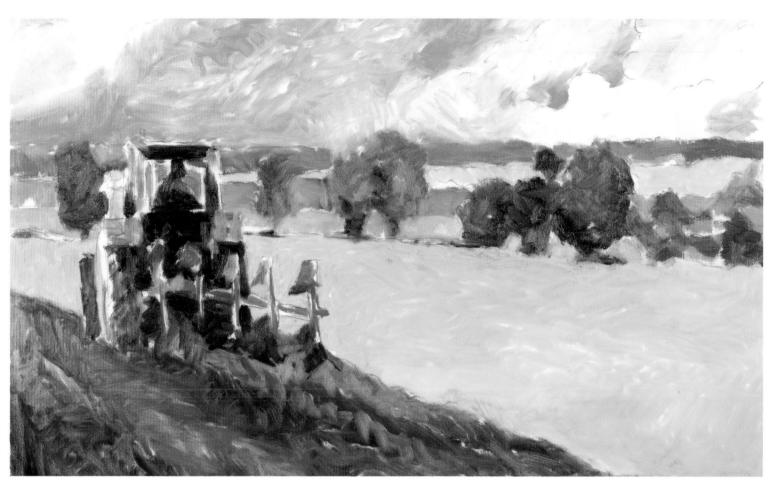

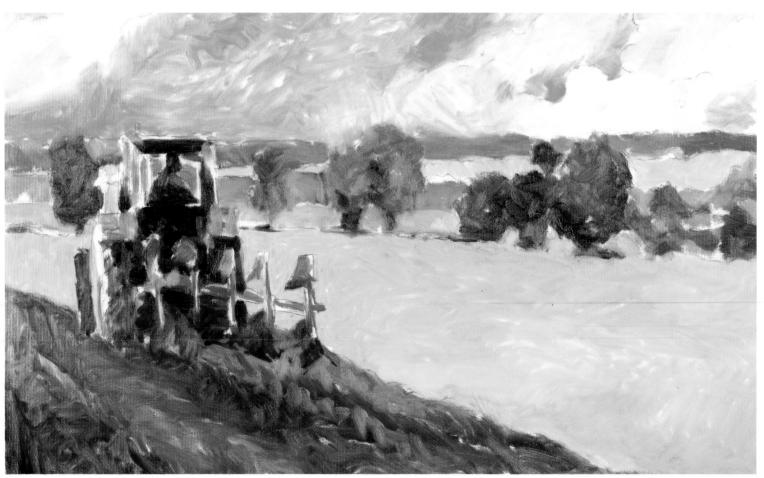

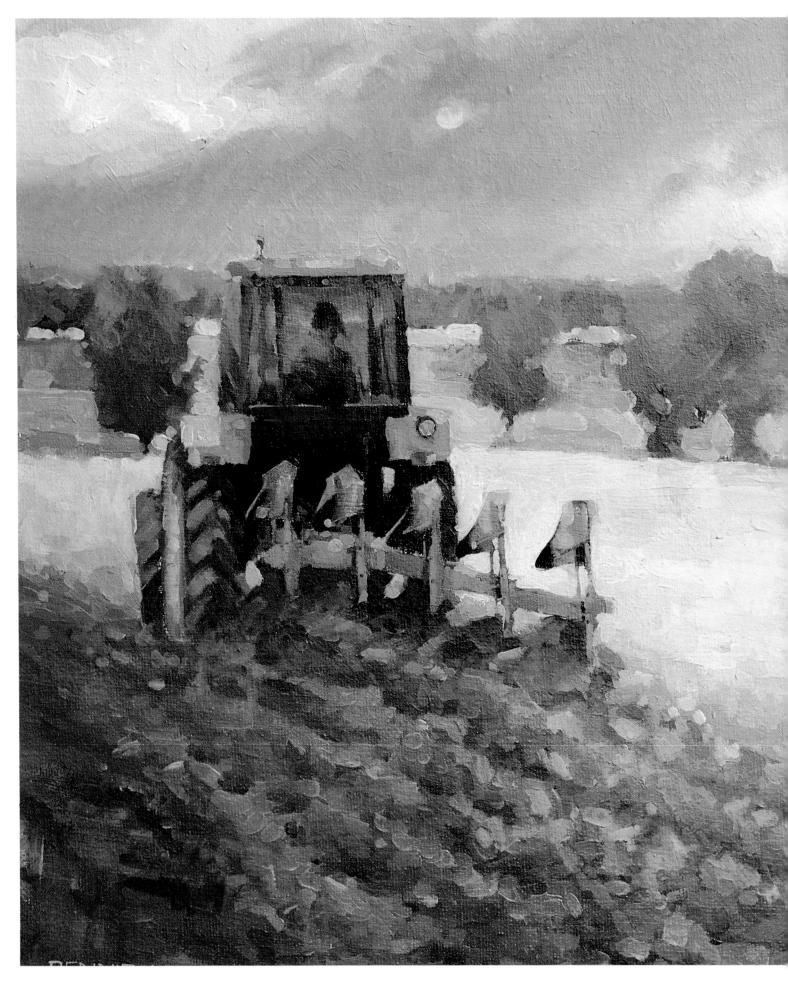

Step 3: The effect of the final stage is one of a more detailed picture which still retains the freshness and spontaneity of the original scene.

A selection of landscapes using a combination of oil pastels and oil paints. It is often a good plan to make the preliminary sketch with pastels and to finish off the details with oil paints.

Facing page: Four step-bystep palette knife paintings, with the finished townscape on page 50.

Step 1: For this street scene draw in guidelines with a stick of charcoal.

Step 2: First lay on broad layers of colour, keeping the paint texture quite thin. As soon as you apply the paint your guidelines will start to disappear.

Step 3: Gradually build up more surface detail.

Step 4: Start to indicate the figures and generally put in more detail.

for the best. Look and assess. It may be a brook in deep shadow, overhung perhaps by trees and foliage, and the only evidence may be a few highlights, establishing that it is water. Reflections in water vary enormously, and it is vital to spend a bit of time observing them, not assuming that you know the theory. Reflections are vertical; they do not slope away with water currents or vary according to where the light is coming from. Objects protruding from the water can seem to be behaving very oddly, due to the phenomenon of refraction.

All that applies to landscape is true of townscape, but in townscape there are more straight lines, more verticals, and it is simpler to see the effects of perspective, which makes it easier to set things correctly in space. But you cannot put in a vague shape and decide that it is a tree. Good drawing underpins a townscape, even if it is not obvious. The vertical lines and shapes must be absolutely upright and nothing is more annoying than to have sloping buildings. If there is any doubt about it use a set-square, but one of the advantages of oils over water-colours in townscape is that you can constantly correct before the paint dries.

Townscapes can look odd without people, and as you will probably be painting them when not many people are about, such as a Sunday, you may need to add them in, no difficult matter if you use perspective lines to insert them in the appropriate place, and you utilize guides, such as the doorways of buildings, to help you. Depending on the degree of detail in your painting, you can insert the figures either fully worked out or as a slash of paint with a lighter colour on top to represent the face. It is important that the shadows of inserted figures or objects of any kind go the same way as buildings and the fixed items in your picture. Groups of people can be represented as an uneven shape with small blobs on top to indicate the heads. Legs may not be seen, hidden in the shadows.

Cars and other vehicles can contribute to the authenticity of a street scene, and can be indicated roughly or exactly, but if you feel that this may tax your ability put them in as accents of colour in the middle distance. Cars drawn from memory may surprise; they will probably be lower in height than you think (a man of average height can lean his elbows on the top of a saloon), and the top section of a car is far less important and will stand out less than the body. The windows may be opaque rather than transparent, dependent on the way the light is coming, and as cars are taken for granted they should be looked at afresh, as ingredients in a picture not a means of transport. As shadows often block off part of the wheels, you may not

have to draw freehand curves, a difficult task for some, and a suggestion of curvature may be sufficient.

You may be happy with your landscape or townscape, the subjects are behaving themselves and are sitting nicely in space with the right kind of shadows, and you have taken the orthodox road of painting from dark to light, not as in watercolour, light to dark. But perhaps it is not 'hanging together', there are too many elements fighting for supremacy, even if you have got the tones right. Perhaps you have got the technique; but perhaps you have not composed a picture. You have let colour take the upper hand. The answer is simple – tone it down or tone it up, toning it down being usually the most advisable.

In oils there are several ways of doing this. The simplest is to use a transparent glaze to subdue the whole picture; another way is to apply a scumble of dry paint. Another, which involves more repainting, is to look at the picture again, see if the focal point is well accentuated – and if it is a worthy focal point – and decide to modify the colours. What is the highest colour you have? There is no question that it is white. And white must be reserved for special occasions, such as highlights. In a landscape this can be a window which is striking the light; or it can be a splash on water; but clouds are white, the old whitewashed barn you have so diligently put in is white. What do you do?

If you want to reserve your white for the highlights, you have to put grey into the clouds and the barn, so that they are not competing for attention. With the very light tones lowered, others have to be adjusted accordingly, with vellows being blended to greens or, maybe, if a warm feel is wanted, a touch of orange; with greens sobered down by adding red, and perhaps a blue sky retouched with yellow ochre. The degree of dilution depends very much on how important you want your focal point to be, and whether it shares top billing with something else. Naturally you can take all the tones down drastically, perhaps with a very pronounced dark, and then bring up certain of the tones you want, so that they glow.

Landscape and townscape are perfect for palette knife work. Painting with the palette knife should be tried at an early stage, and the process has something in common with pastels in that you create a complete picture in a few minutes. Many newcomers to oils, people who are perhaps adept at watercolours, are reluctant to use too much colour, and get into the habit of using very diluted paint. There is nothing wrong with this, but if it is done continually it can become automatic, and the painter never

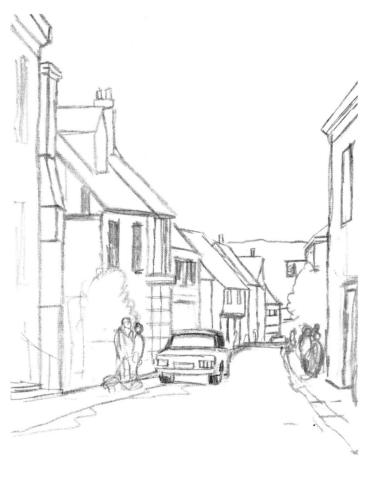

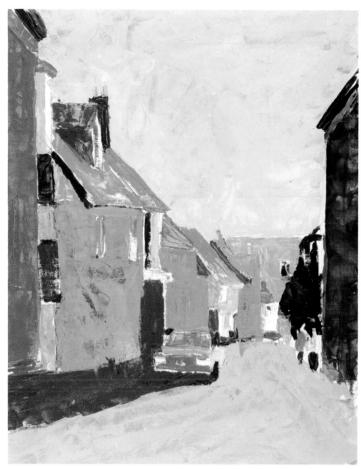

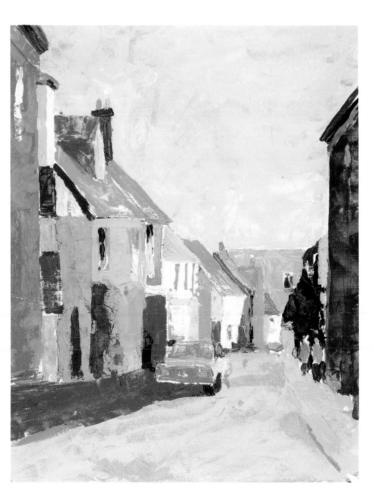

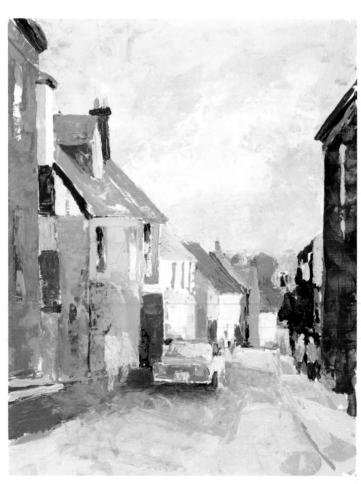

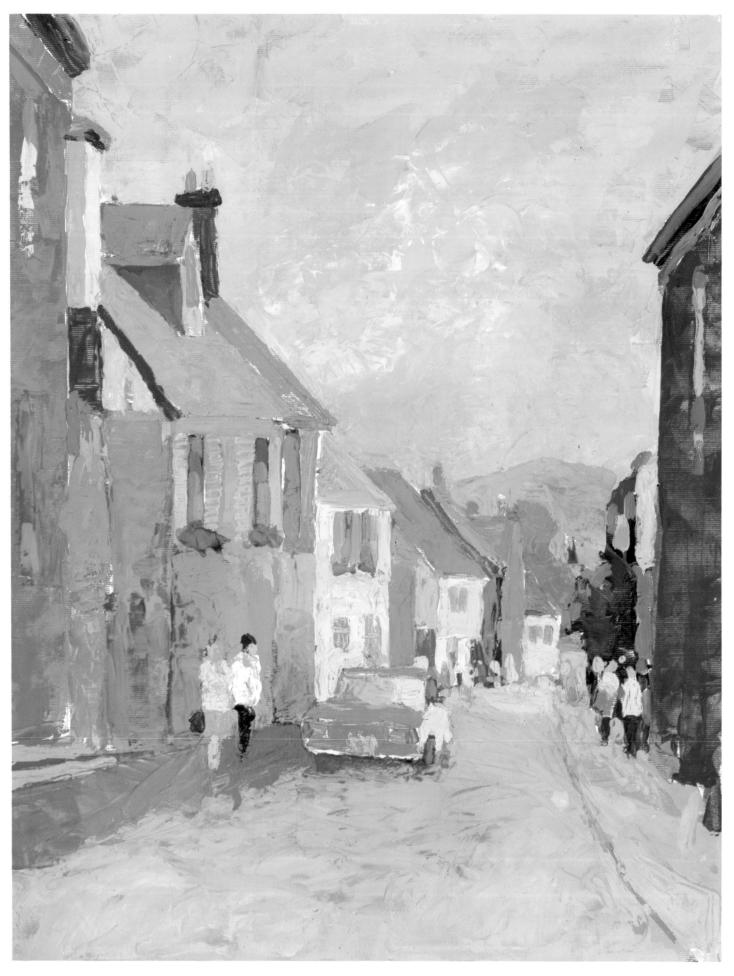

Left: In this, the final stage, build up thick layers of paint, working on the picture as a whole rather than concentrating on unnecessary details.

Right: Detail of clock tower.

Below: This impressionistic view of King's Cross, London, was painted almost entirely with a palette knife and the artist has used subtle colour to convey the mood of this wet November day.

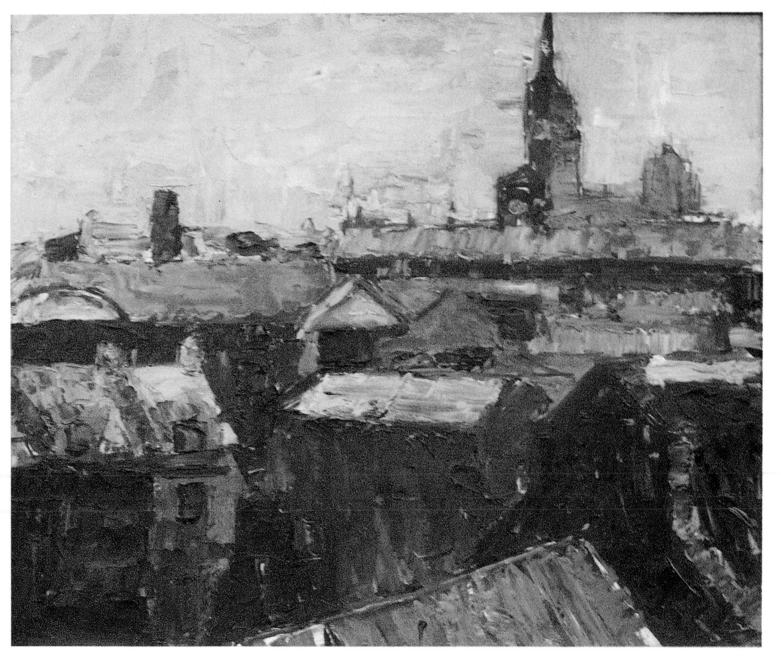

gets the kick out of handling thick luscious paint. With a palette knife you have to use thick paint, for otherwise you get an oozing uncontrollable mass dribbling off the knife. But when using the palette knife there is no need to be dogmatic, and for fine details a fine pointed brush can be employed, perhaps nylon rather than sable because of its long-wearing attributes. And, of course, you can carry through a picture using palette knife and bristle brushes, changing from one to the other as the need arises.

Preliminary sketching is usually dispensed with, and the masses are applied directly with the knife, holding it sideways and using a broad sweep, which will lay the paint down in a curve with a straight edge. Vary the sizes of the palette knife to suit. It is advisable to have a clean unmuddied palette, leaving plenty of room to mix colours. Palette-knife painting is best with a bold approach, knowledge of what you are going to do, and a willingness to wipe paint off in one fell swoop if the picture is getting out of control and the colours have lost their crispness.

Some artists advise the use of two palettes, one for the basic construction, one for the lights and extras. The basic colours are first mixed on the palette; mix plenty of it. Construct your shapes with this. The 'incidental' colours can be mixed later when you have become certain of the tones. Bear in mind the solids themselves and the spaces they form outside themselves. This is important in all painting in oils but especially so with palette-knife work. When the basic tones have been put in, the filling-in can take place, using the knife flat for smooth effects, the point for detail, before taking up the brush. As with all painting, you do not have to stop at an 'edge'; you can bite into the previous layer at any time. The brush can also be used to give texture to the paint spread down with the knife.

The palette knife is often used for sea pictures; it is impossible to better when building up waves, and the very stroke of a loaded knife wielded horizontally can create convincing waves immediately, down to the flecks of foam. The open quality of sea pictures means that the palette knife does not have to be poked into little corners which it does not quite fit, and the knife is perfect for huge expanses of sky.

Sea pictures are a favourite non-professional art form, but their apparent easiness is deceptive. Waves are so distinctive a subject that they can be recognized immediately (whereas a stream may look like a path and a tree might look like a floorcloth on a stick); but because waves are recognizable it does not mean to say that they are good waves.

Sea Pictures

There are numerous methods. Here is one, traditional but not unadventurous. The subject involves rocks and a raging sea with plenty of spume and spray. Five mixtures are made, each for a specific purpose:

Sky: ivory black, titanium white, green oxide, mixed to make a cold grey.

White surf: Mostly titanium white with a little of the sky grey.

Green water: viridian with a little of the white surf mix.

Light rocks: burnt sienna and viridian.

Dark rocks: ivory black and cadmium red to make a greyish-violet mix.

This way of dealing with colours, mixing them deliberately for a set purpose and not deviating from the pre-arranged plan, is very useful in all subjects, not just sea pictures. When there are so many colours to choose from, it prevents chaos. L. S. Lowry did much the same thing, using a very restrained and limited palette, as you will read in the section on colour schemes near the end of this book.

The canvas is first of all painted with raw umber and turpentine rubbed on with a rag and then wiped off until the canvas has taken a stain, which will be approximately the same density as the sky. With a piece of cheese cloth the light areas of surf and splash are then wiped off. The rock area is then roughed-in with a large brush, then gone over with a smaller brush emphasizing the darker tones and outlining the various planes or sides of the rocks. The movement of the water is then tentatively suggested with light use of the brush. At this stage the picture is more or less monochrome. The full colour is then applied, trying to express textures and movement with direct brush strokes. Dark water in the distance and dark lines in the foreground rocks are added near the end; and finally light touches and highlights, and a final going over with dark rock mixture to suggest wetness on the rocks.

Another method is to apply a thin stain to the canvas, which serves to take off the glare of white. Draw in the design with charcoal, and then spray with a fixative. Begin with thin turpentine glazes, using brilliant colour, until you are satisfied, and then let the canvas dry completely. Finish with thick paint, guided by the underpainting.

A further method involves painting the canvas in one basic grey, with tone, detail, the highlights taken out with a cloth, until you have what is virtually a picture in monochrome. You then work on this with heavier paint, building up on the underpainting. If you are experienced with watercolour, look on this method as tinting.

Step 1: In this seascape the canvas is first of all painted with raw umber and turpentine rubbed on with a rag. Some areas have been wiped away to suggest surf and spray.

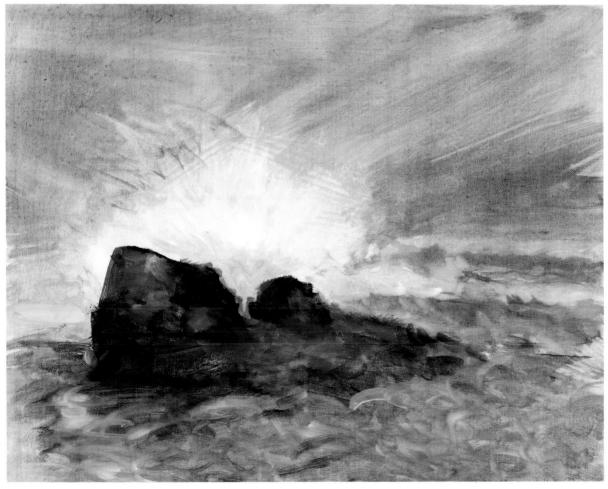

Step 2: The rocks are painted in with a one-inch flat brush. The movements of the waves are then sketched in very loosely with blues and whites.

Overleaf: Step 3: The finished picture. Full colour is now applied and the rocks are made to look wet. Surf and spray is painted with blues and greens mixed with white to achieve the desired effect.

In 'pure' sea pictures there are three basic elements - the sky, the sea, and the rocks. Movement is the most distinguishing feature of sea pictures. Clouds play a very important part, with regard to colour and shape, and these are flexible which you can adjust any time. Although the sky may be only a small strip at the top of the picture, even outside the picture, the artist must be always aware of its effect on the water. Sometimes the sky is too brilliant or too light in tone, in which case it is transposed down a tone or two to make a picture which hangs together. Water can be divided into three divisions – that in the foreground, that in the middle distance, and that in the distance. The water in the foreground is the most difficult to paint, that in the middle distance the most important, and distant water the easiest because it appears the most placid. It is generally found most convenient to paint the middle distance and distance first, leaving the foreground, both rocks and water, last.

Many marine painters find their focal point in the central section of the canvas; the central section can be defined as the space inside an imaginary line drawn all round the picture a quarter of the way inside the canvas and it does not have to be an imaginary line; if the paint is wet, you can pick out the central area with a pointed instrument or the handle of the brush. The main feature of the picture may be a breaker coming in, a wave breaking, or a wet rock gleaming in the sun, and everything else may be subordinated to this. A common fault of novice pictures is that there is no focal point; each item in the picture has equal prominence. Whether it is a landscape, a sea picture, a still life, or a portrait, the technique is the same for bringing it out – lessening the contrast of tones outside the main feature, lowering the tone of lights, raising the tone of darks, and softening any sharp edges which seem to grab the attention.

A way of looking at this focal point is to imagine a spotlight directed at it, with the illumination fading as it reaches the outer edges of the canvas. Forms inside the spotlight area will be sharp and contrasting. This principle has been practised by all the great artists of the past, including Rembrandt, Titian and Vermeer; it is often a good idea to look at reproductions of their work, forgetting the subjects which may be so familiar that we have ceased to examine the pictures objectively, and noticing how they employ the spotlight effect.

Many artists, whatever field they practise in, make small watercolour drawings before they set out on a time-consuming canvas, and it is always advisable to keep a sketchbook with you and when something strikes the eye jot it down.

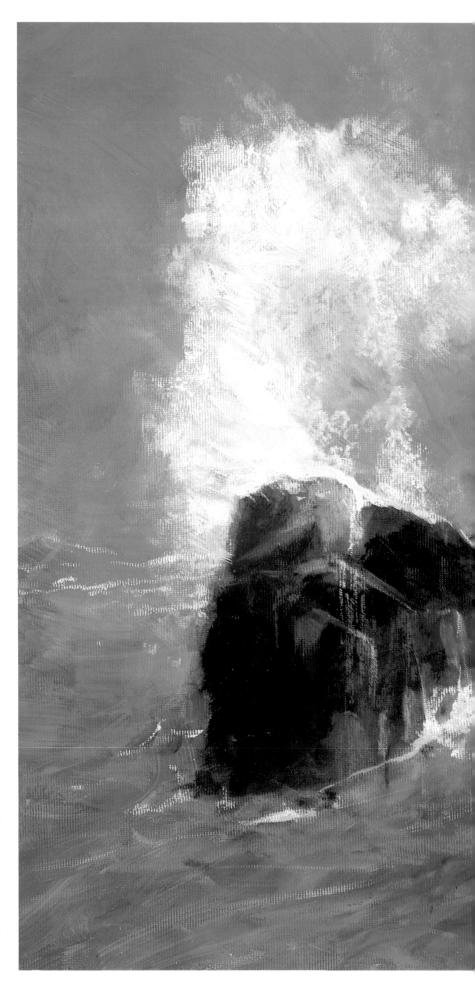

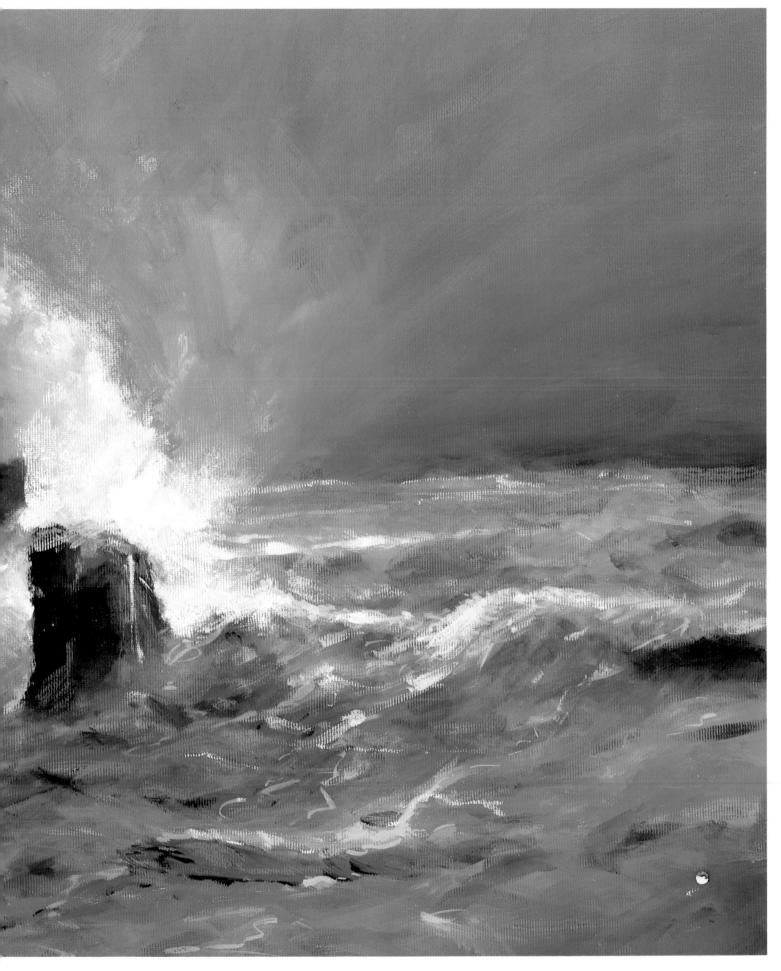

Right: A portrait using a very simplified technique.

Life Drawing and Portraits

Oils are a marvellous medium for figure work and portraits. The painting of the human figure is unquestionably a challenge. If you can paint a nude you can paint almost anything. It is not difficult, though it is better to start off with charcoal and pencil than to launch straight away into oils. The best way to enter this area of painting is to join a life class, perhaps at a night school. Do not be embarrassed or alarmed that the standards may be too high. They will vary greatly. In any case most newcomers feel nervous at first. Students of all ages can learn from each other as well as from the teachers. Art classes usually last about two hours; this may not be long enough for some artists to carry out an oil painting, but does allow plenty of time to prepare sketches and crayon or pencil studies for taking back home, where you can complete the oil painting.

There are numerous ways to approach the task. A brief charcoal outline, building up with shadows, and then filling in with paint; putting the background shadows in first and laying out the figure against these; putting in the figure in a single neutral colour much diluted with turpentine and then overpainting with thicker paint; the same process using a palette knife instead of brushes; doing much the same thing with a neutral tint in acrylic and using oils over it at once as acrylic dries very rapidly; making a meticulous drawing in pencil and then filling in with soft brushes, the equivalent of tinting in watercolour.

Here is a straightforward and traditional method:

The colours are put on the palette – burnt sienna, burnt umber, ultramarine, vellow ochre, viridian, and flake white. Three further colours are prepared for the final stages - lamp black, vermilion, and crimson lake. The drawing is indicated in thin burnt umber using turpentine as a medium. Massed shading is added, using a larger brush, but still in burnt umber. The colours are added, rapidly, using plenty of turpentine. The canvas is toned down. The picture is built up with heavier pigment using a mixture of turpentine and linseed oil (or a prepared shop-bought medium). The drawing is corrected, and a small sable brush is used for the eyes, lips, and other detail, employing the additional colours. A soft clean brush is then applied, merging some tones and softening any hardness. The figure is in focus, the background is blurred. An oil painting of this kind, size 24 in. (61 cm) by 20 in. (51 cm), can be completed in two hours, just enough for a life class session.

How good must the drawing be? It depends on what sort of picture you want. If you can get

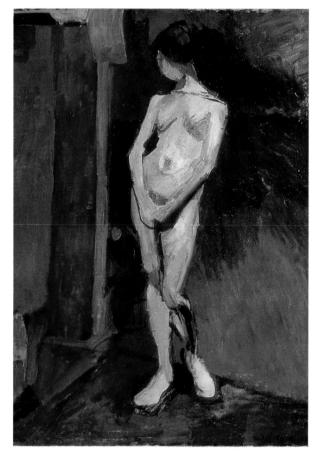

The nude study (right, below) by Henri Matisse is an excellent example of how effective simple brushwork can be.

Details of far left, top

the effect of solidity and flesh you are halfway there. A compact pose is easier than one all arms and legs. A seated figure is easier than a standing one. The main thing is to look and assess; how long is the arm? (Measure it against something else by holding a closed fist at arm's length, projecting the thumb, and using it as a measuring instrument. The arm may be threequarters of a thumb; a leg may be a whole thumb; the head may be a thumb-nail.) Paint what you see not what you know is there; anybody can draw a mouth and have it recognized as such. But when a mouth is looked at in certain lighting conditions it may only be seen as a shadow beneath the lower lip and a thin line where the lips meet. If you are uncertain about your drawing abilities, mentally tone the whole thing down, as though the figure is in deep shadow, and bring out details here and there - a suggestion of the face for example. If you feel that you cannot handle perhaps the most demanding piece of anatomy, the hand, leave it in darkness. Do what you know you can

Where do you start? It is up to you. Some start with the head, some the torso, extending outwards to the arms and legs, indicating them at first tentatively, then more firmly. Remember the proportions: a man is eight heads tall, a woman six heads tall, a child of one four heads tall. The halfway point down of a man is the crutch. The neck does not sit on the shoulders but is inset; a man's neck slopes outwards, a woman's neck slopes inwards. The hand is not in one plane like a flatfish; the thumb droops unless the hand is outstretched. The eye consists of three parts, pupil, eyelids, eyelashes, plus a pouch beneath the eye. The most important part of the foot is the ankle; if it is badly placed a foot looks like a leg of lamb.

Solidity is more important than accuracy. If the body looks like it is made of plywood add shading, toning round the body, watching where the ribs make minor highlights, or take off colour with a rag, letting the canvas show through. If it is lightly tinted it will provide a mid-tone which you can work on. If, by using a brush, you are unable to get right the transition between the tones, use your finger tips.

When you are applying colour remember that you do not have to stop at the edges. You are not colouring an outline in a children's book. Outlines are a convenience. You use them when you want them, discard them without mercy when you do not.

Many artists when it comes to doing costume

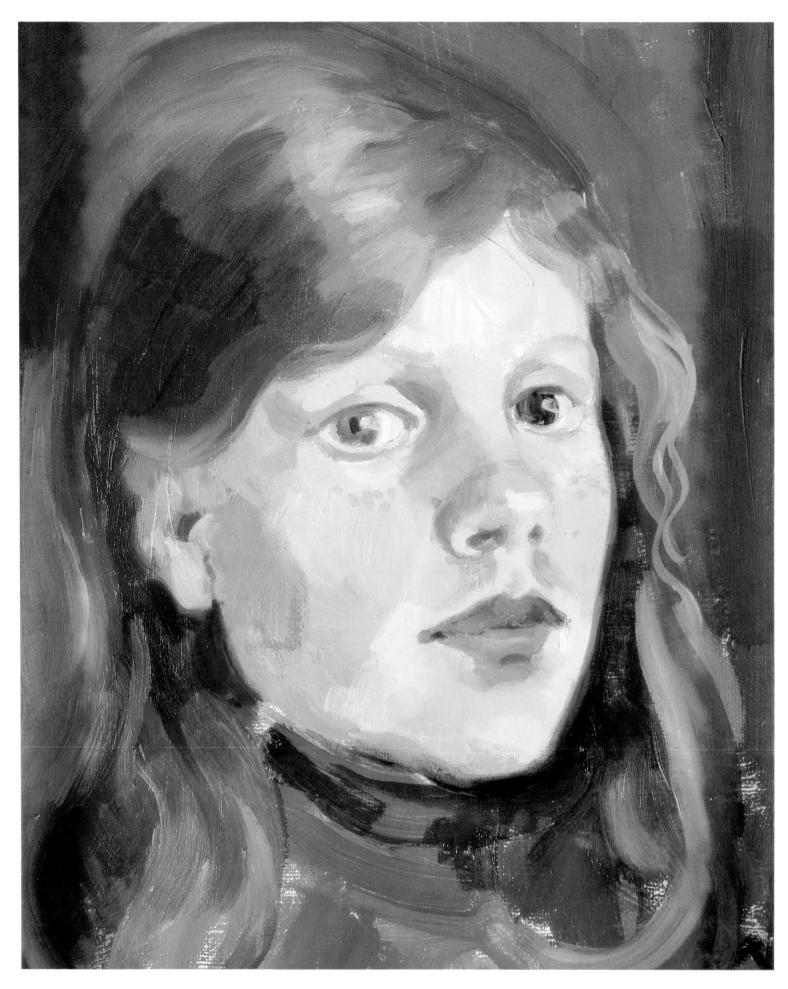

figures often depict their models nude then add the clothes later. The pose of the figure does determine how the clothes hang. Folds in clothing come in four kinds – folds in hanging materials, folds in pulled materials, folds in heaped materials, and folds in crushed materials. All are expressed not with changes of colour but changes of tone. The local colour can be tinted with a grey or other neutral, depending on the overall colour scheme. Patterns, unless they are aggressive, should be suggested rather than copied.

Portraits have to be accurate, otherwise there is no point in doing them. When marking in the features, there are useful aids. The eyes are halfway down the head and the tops of the ears are at the level of the eyes. The distance between the top of the forehead and top of the nose is the same as that between the top of the nose and the bottom of the nose. The distance between the top of the upper lip and the bottom of the chin is the same as that between the top of the ear and the bottom of the ear. Of course there is some variation; otherwise we would look all the same.

Many portraitists start with the eyes, building from there. One standard method is this: Tint the canvas. Draw the outline of the head in charcoal, choosing a three-quarter view as this provides better shadows. Put in the features with a soft brush, using a brown such as burnt umber, well diluted with turpentine, and fix the shadows. Take the same tint lightly over the face, building up gradually, putting eyes, nose, mouth with heavier colour, and affirming the shadows. Indicate the lines of the neck, stressing the pit of the neck, vital for setting the head on the shoulders. The hair is put in lightly, stressing the direction of the growth and the way it is massed, and the colour added, but be careful not to overload the picture with too much dark. Put in the background. Work on where the face abuts the background, remembering you can go over the edges. Tone down where necessary, taking out pure whites and reserving them for highlights (tip of nose, bottom lip, highlight in eyes – same place each eye). Soften tone-edges which are too sharp with a soft brush. If the head is merging with the background take an off-white and go round the head with a soft slow brush.

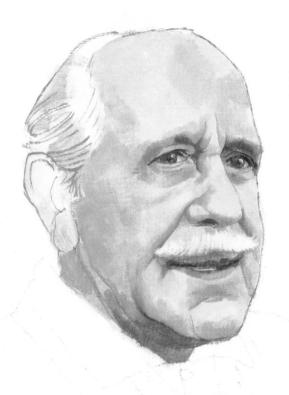

This page and far left:
Different portraits
demonstrate a simplified
method of painting. It is vital
not to overwork the picture,
which could end up as a
muddy mess.

Painting a face in profile is a quick method of obtaining a good likeness.

A three-quarter view portrait creates its own problems.

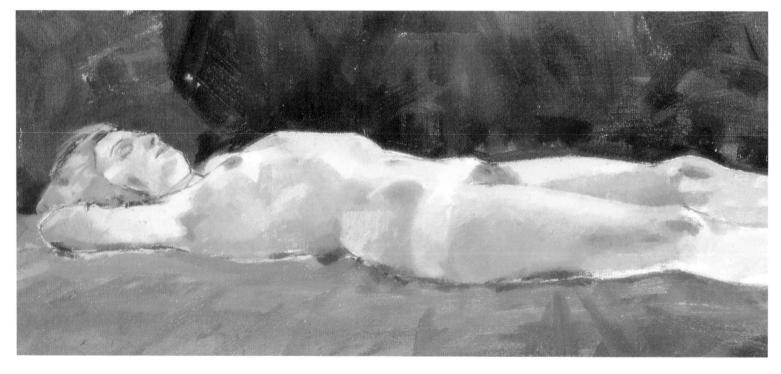

Still Life and Flowers

Still life is a splendid 'starter' subject. You can make the selection as easy or as difficult as you wish. The main thing is to bring all the objects together to make a whole, so that the picture is not a mere catalogue; therefore, as with all other subjects, you need a focal point to which the eye is drawn. You can begin in many ways such as a charcoal outline, broad masses with the tones added later, shadows first, objects afterwards, speculative drawing in burnt umber with the brush, filling in first with thin paint then adding thick paint. But all subjects can be tackled in the way *you* prefer. When doing a still life think of the spotlight metaphor, picking out something with the light dissipating

towards the edges of the canvas. Top colour, raw colour, is reserved for the featured object – a bottle, an apple, a jar, a bunch of flowers. The rest is sobered down, the background fades into insignificance. Use colour to suit yourself, tone it down so that you don't know whether it is greeny-grey or browny-purple. It is easy to paint brightly; not so easy to be subtle and evocative. It is simple to put paint on a canvas, simple even to depict articles so that they can be recognized. It is rather more difficult to put solid objects in space in such a way that they belong together and are not strewn across the picture surface; but not that much more difficult. Look, assess and paint. The secret of success is in your hands.

Left: Step 1: In this still life, the subject has been sketched directly onto the canvas using yellow ochre. This colour has been chosen because it is in sympathy with the colours that will be used in the finished painting.

Far left, bottom: It is not often that artists have the chance to paint a nude figure out of doors. In this picture, the artist has managed to capture the feeling of sunlight.

Step 2: Using a one-inch soft, flat brush, sketch in the main areas of colour and keep the brush strokes very loose.

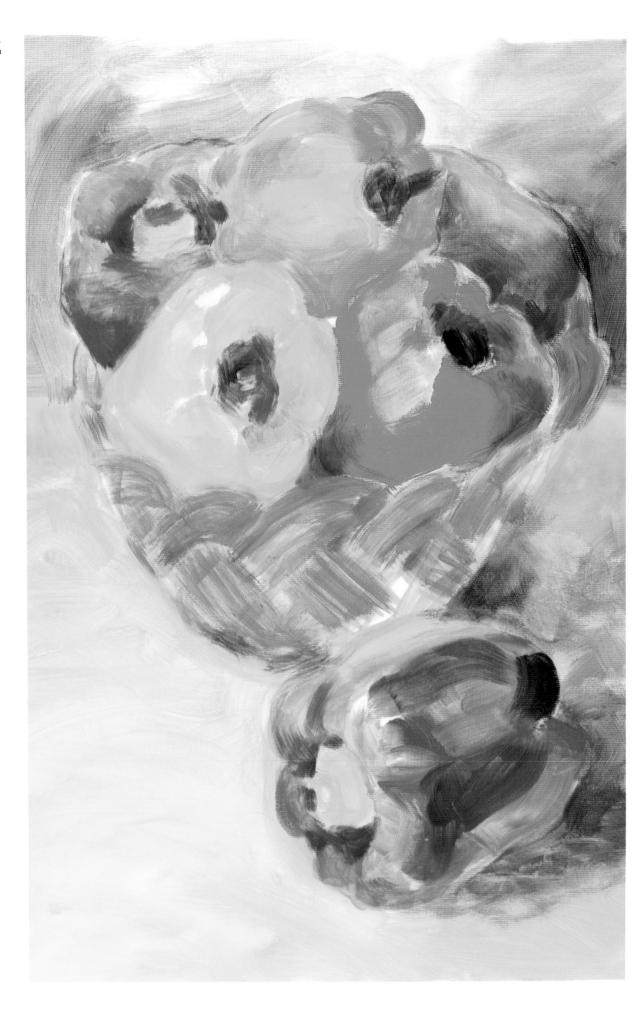

Step 3: In the finished painting the contrasting highlights and shadow areas have been added.

Wherever you live you will always find something interesting to paint .Try to catch the subject matter when the light is at its most attractive.

Top right: This captures the effect of the birch tree in a strong autumn wind. Thick paint straight from the tube is applied with a stiff brush, allowing each successive layer of paint to dry before adding the next.

Bottom right: The vegetable garden can contain many attractive subjects to paint, such as these cabbages. This effect was achieved by thin scumbled layers of oil paint revealing the umber background colour.

Far right: Sunshine is not always vital to your painting. These geraniums were painted on a dull day using a combination of techniques. The background is scumbled and thinly painted while the foreground flowers and leaves are composed of thick layers of colour.

Far right: In this painting of a mill, the atmospheric quality is achieved by using only a very limited palette and simplified brush strokes.

Above: Detail of reflection.

Right: Only the merest suggestion of a change of colour and brush stroke is enough to indicate a figure.

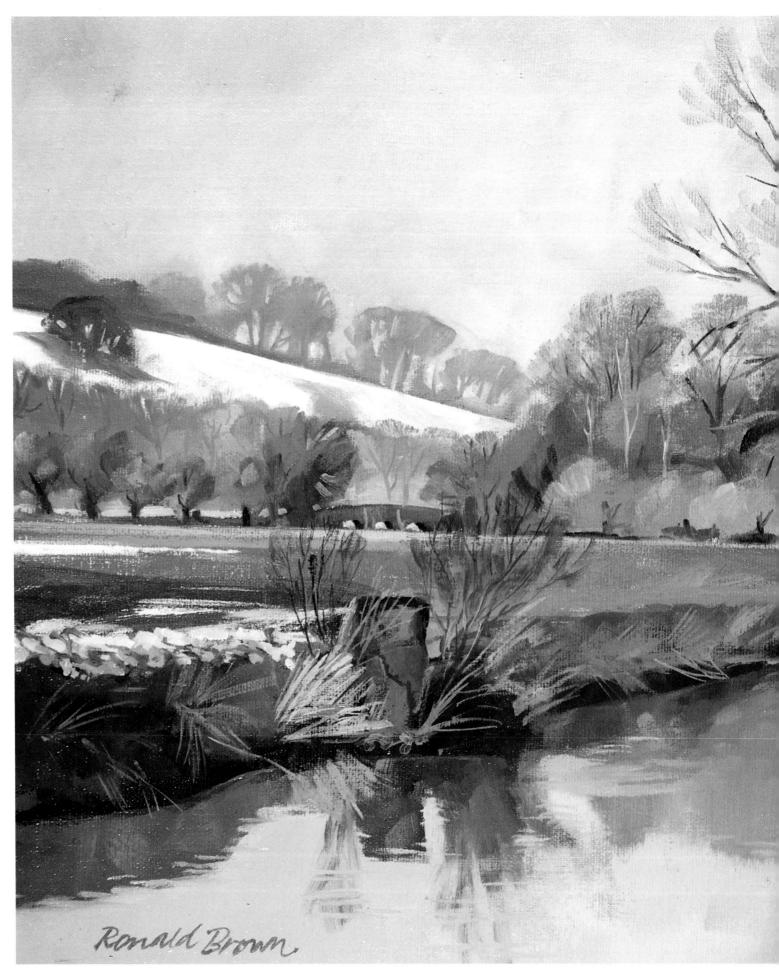

Above: Detail of reflection in the water.

Left: Note how the artist has used aerial perspective to give the feeling of distance to the trees in this detail.

Far left: This winter landscape makes a satisfying composition. The dramatic lines of convergence give conviction to the perspective. Interestingly the vanishing point would be behind the tree.

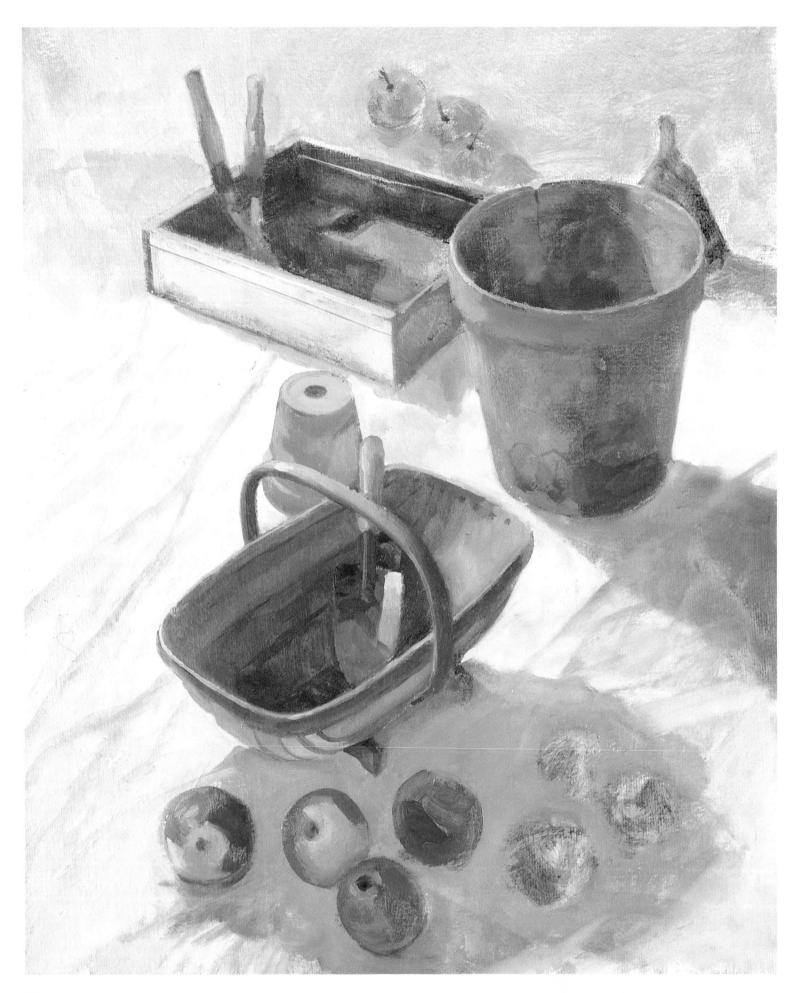

There is interest even in the most mundane of subjects. There is no house or garden, however small, which cannot supply the observant artist with an interesting composition, as shown in the collection of paintings on these pages.

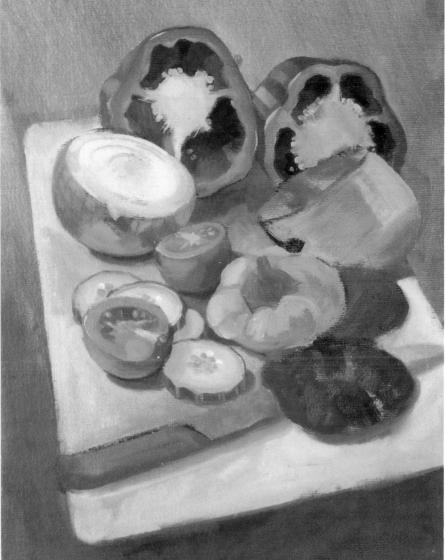

The details (*left*) of the basket and the flowerpot show subtle tonal shades where highlights are accentuated by the depth of the shadows.

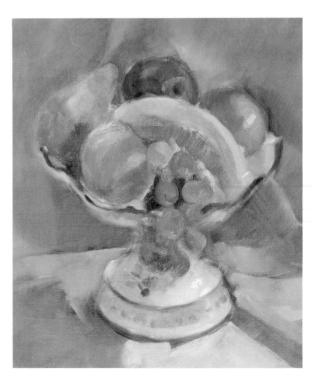

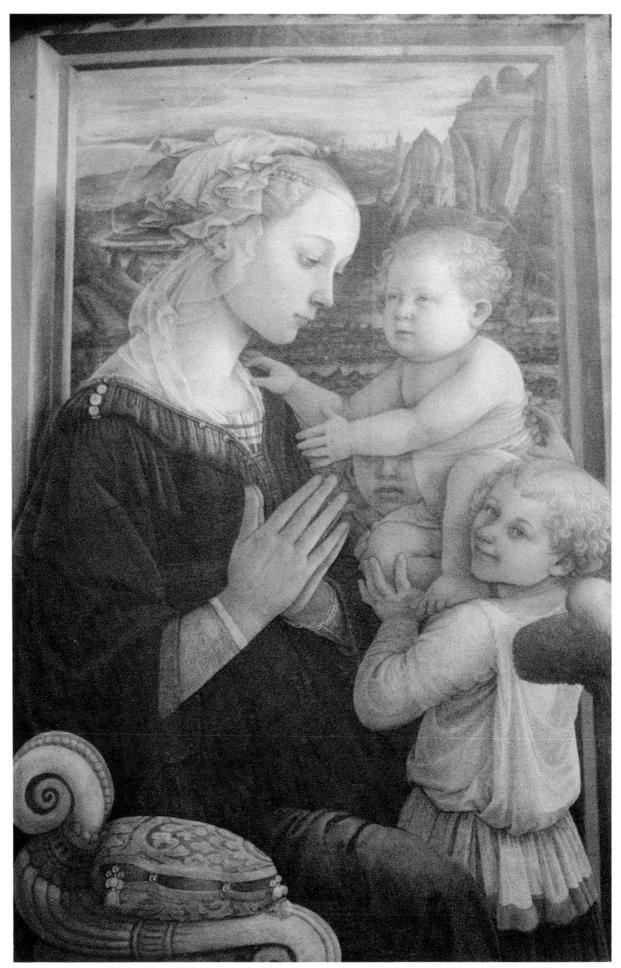

Renaissance artists had to rely on good quality surfaces to enable them to paint in such exquisite detail. They had only canvas or walls on which to paint, thus paintings on wooden panels tended to be small as in this *Madonna and Child* of Filippo Lippi.

ADVANCED TECHNIQUES

There are basically two methods of painting, in whatever medium. There is the direct method. as advised by the Impressionists but not always practised by them, in which the paint, usually opaque, is put on in one application, and there is the building-up method, in which the paint is put on layer upon layer (in watercolour wash upon wash). The second method is the most time consuming, and an artist can spend months, even years, on a large picture, to the detriment of his output. These pictures may not be very good, but they certainly last, and any Italian Renaissance picture (say from the 14th to the middle of the 16th century) is sure of a warm welcome whatever the level of competence.

Painters of that time – and much later – had to be proficient in the art of colour-making as well as picture-making. In 1675 the competent but immensely boring portrait painter Sir Godfrey Kneller employed a man solely to make his colours. The artists' colourman dates from about the middle of the 18th century, and in 1776 a certain Matthew Darly was advertising 'transparent colours for staining drawings.' Reeves introduced small soluble cakes of water-colour in about 1820, followed 10 years or so later by Winsor and Newton, who put their watercolour into pans. In 1847 Winsor and Newton introduced watercolour in tubes.

Renaissance artists not only mixed their own colours, but they prepared their own surfaces, usually panel, often of poplar. They coated the panel with gesso, which provided a sound link between panel and paint, and provided brightness beneath the coats of paint. When this was not wanted, the white was toned down with a wash of transparent yellow (the 'imprimatura'). The main outlines of the forms were transferred from the drawing, using the 'pricking' method. At regular intervals holes were pricked into the drawing, and charcoal was dusted through these holes on to the panel, recreating the design. An alternative 'squaring-up' method much used today, is explained in the volume on Drawing. The Victorian Lord Leighton used the pricking method extensively.

The outlines were then emphasized with grey, black or brown ink or paint using a fine brush or a quill pen, with sometimes hatched strokes put in to indicate modelling. In the 15th century a monochrome wash of grey or brown was applied as an underpainting. Then the successive layers of transparent colour were applied. Duccio (c. 1260–1320) used green underpainting for his flesh sections. Green is

the complementary colour of the flesh tints, and when the local colour (the 'real' colour) was introduced this green came through the layer above and provided shadow. It was found that adding grey or brown to the flesh tint could result in a muddy colour. This green wash was allowed to dry, and then overpainted with a transparent wash of 'verdaccio', a mixture of black and ochre. This wash, in turn, was then left to dry.

The green method was very popular among the Italian artists (but not elsewhere). The next stage was the application of the local colours. The flesh tints were applied in separate hatched strokes, starting with a middle tone, white being added for the lighter parts, and the shadows added last. Hatching was used elsewhere, along with evenly graduated washes. Blues in drapery and skies were underpainted in a light dim blue, and the vivid reds were applied over a wash of red ochre and white. This first wash was deliberately uneven, adding variety to the final overpainting.

Above: Here, in total contrast to the previous old master painting, the artist has made a quick sketch of the two children having a bath, and he pays no attention to technique or method and even allows the white canvas to show through in places.

Right: The Adoration of the Shepherds by Peter Paul Rubens.

Elsewhere in Europe similar techniques were being employed. The Flemish painters used a lot of ultramarine in their shadow areas, and a soft green was used under blue, particularly when the draperies were of this colour. Titian (c. 1487-1576) came more than two centuries after Duccio, but he still followed the sequence of underpaintings, except that his handling was far freer, and his underpainting of the flesh (except in the deepest shadow) was darker than the overpainting. The underpainting served as a foil to the later layers, and washes of blue and red were applied seemingly at random. In the 16th century there came a demand for clever effects and dramatic light and shade. Instead of an underpainting in transparent browns and greys the whole of the canvas was primed with brown, sometimes verging on black (El Greco was particularly keen on this). The local colours were put in light and weakly, built up with brighter colour in a dashing manner. The flesh was begun in pink, modelled with madder and black so that the effect was grevish, then boldly overpainted with light flesh colour. El Greco often dragged a dry brush of the light colour over the underpainting so that contrast is

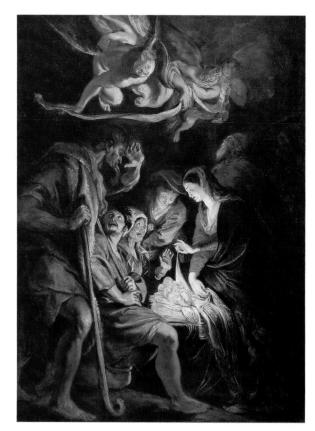

Below: Portrait of a Man by Titian.

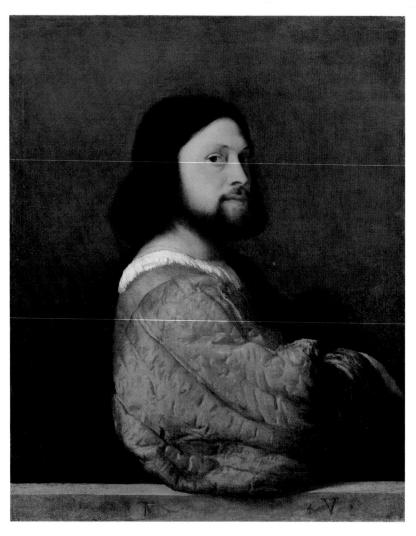

heightened. To give brilliance to his draperies, the underpainting was very light, with a good deal of white mixed in with the local colour.

Rubens (1577–1640) came a century after Titian, and was in a position to see that oil paint becomes transparent in time and that the Italian style of brown underpainting had unforeseen consequences as it was coming through the upper layers. Rubens used a brilliant white ground, toned down with yellow imprimatura, and then he applied a grey underpainting, probably using a sponge dipped in size and ground charcoal. He dragged this across the panel in parallel strokes, not completely covering the imprimatura, so that light paint would stand out better than an all-over grey wash. The underpainting was then carried out in transparent brown.

The flesh tint was laid out thickly on the part to be light, and dragged thinly on the shadow areas, and highlights were applied with pure white. Rubens worked fast, and achieved spontaneity, and may be said to have found a formula that suited him perfectly. Rembrandt (1606–1669) had a formula too – lots of shadow, not much light. He used a medium-brown priming on his grounds, modelling in a greenygrey colour, much darker than the final light tone, not so dark as the final shadows, and this gloom obliged Rembrandt to rely heavily on the medium and light colours in the concluding stages.

Left: Woman Bathing in a Stream by Rembrandt van Rijn.

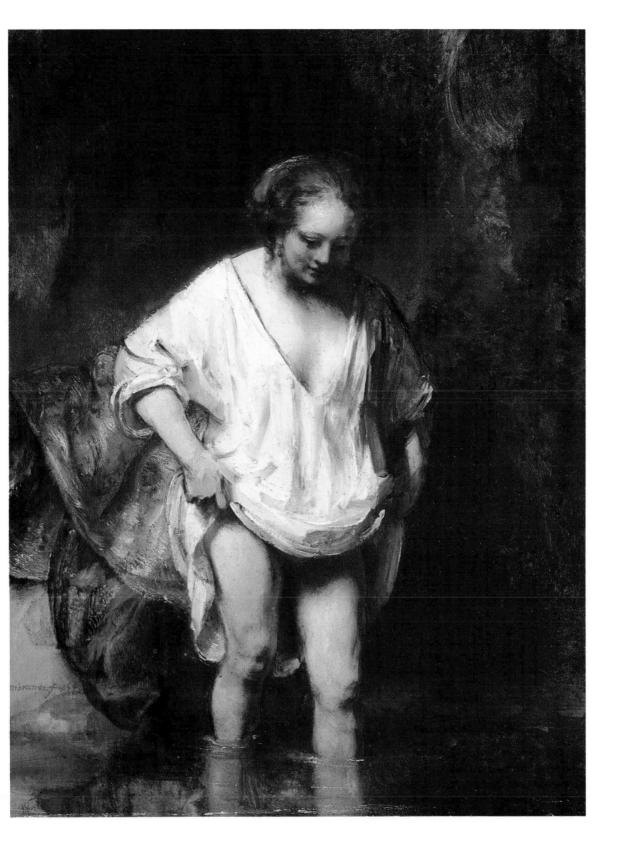

Rembrandt and painters like him paved the way to direct painting ('alla prima'), and after the orthodoxy of the early Italian Renaissance painters there was an eagerness to experiment. Caravaggio (1573–1610), although a generation before Rembrandt, looks forward in his theatricality and tight control to a later age, and he was one of the first to be preoccupied with a

perfectly smooth finish, using soft brushes and a thin medium, a technique also used by Velazquez (1599–1660). Vermeer (1632–1675) primed his canvas with a brown-grey mixture made from chalk, lead white, umber and charcoal, and it is possible that instead of the traditional underpainting he began by putting in flat areas of colour.

Above: A Child's Portrait in Different Views: 'Angels' Heads by Sir Joshua Reynolds.

Right: Portrait of Edward Richard Gardiner by Thomas Gainsborough. This is a fine demonstration of how the artist used thin glazes to build up such a marvellous translucent quality. Watteau (1684–1721) often worked directly on to the canvas, making amendments and alterations as he went along, and working at great speed, using too much medium with his paint, which resulted in the deterioration of his paintings. Many 18th-century painters also wished to work rapidly, especially those society painters for whom the commissions were piling up and for whom guineas were more important than the verdict of posterity. Among these was Sir Joshua Reynolds (1723–1792), whose personal motto should have been 'Anything for Money', and whose influential *Discourses on Art* he disregarded completely.

To speed up the drying process he mixed wax with his paints, and some of his pictures have six or seven layers, put on in any order, each with a different drying rate. No wonder that after 200 years the surface of his pictures looks like crazy paving. Reynolds was primarily a portraitist, and he began his work by putting in a rough circle of white on the grey priming of his canvas. Onto the white he placed his head, working rapidly and not waiting for the colours to dry before applying further paint, either solid or in transparent glazes. After he had done the face, and probably the hands, he would pass the picture to assistants to do the drapery and background, adding the final touches himself. Reynolds could do a face in a day, and charged on average £210 a picture, the equivalent of close on £5000 or \$8500 today.

While Thomas Gainsborough (1727–1788) is rated higher now, his pictures averaged £168 each, and although he seems to have painted with sump oil he did have some regard for his public, careful in his choice of paints, and not having his pictures brought back to him by his clients for repainting – one of Reynold's tiresome chores. Gainsborough blocked in his portraits with thin highly diluted paint, completing the face before turning to the drapery and background. He painted with great freedom and bravura, but kept his methods sound and

rarely bodged the resulting picture.

John Constable (1776-1837) had a different technique altogether. He began with pencil and oil sketches, and when he worked he put in his main masses in an undercoat, bringing in the detail gradually. In order to make certain the painting would hang together, he drastically altered major portions. Often accused of leaving his pictures unfinished, Constable would round off the painting with flecks and stabs of highlight, sometimes applied with the palette knife. Glazes of reds and browns were used to add substance to the foreground, and he paid great attention to his clouds. If you visit the Victoria and Albert Museum in London you can see a large number of his cloud studies: he was one of the first artists to actually look at them. No one merits such close study as Constable. He used the technique of scumbling (dragging a nearly dry brush loaded with white over a layer of paint to get sea or sky effects) extensively. His colour seems so natural and realistic that it is sometimes a shock to realize that the accents in the foreground are in pure vermilion and that the shadows are in fact green. It must be admitted that he sometimes overworked his paintings and that the oil studies have more

Left: Detail of sky in the painting (below).

Below: A sketch for 'Hadleigh Castle' by John Constable. In complete contrast to the way Gainsborough painted, Constable appeared to attack his canvas. This is particularly evident in his smaller paintings which were often painted on site. Constable's larger works such as The Hay Wain would have been painted in his studio from smaller sketches made out of doors.

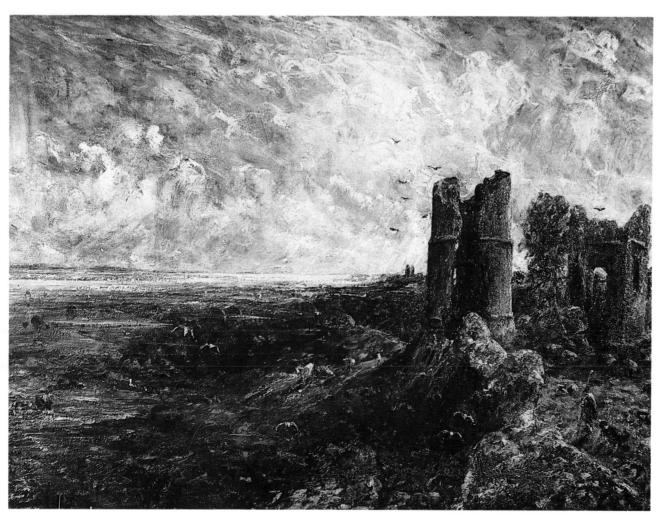

Above: This marvellously evocative painting *The Path to the Old Ferry* by Alfred Sisley demonstrates the pointillist technique used by the Impressionists. The painting was built up by using small dots or brush strokes of colour.

freshness and verve.

J. M. W. Turner (1775-1851) was the great adventurer in English oil painting, and there is a world of difference between his early prim architectural subjects and the mystery of his later light-bathed paintings. He was very keen on colour theories, which have worked to the detriment of his paintings as his yellows have proved fugitive and some of his pictures have taken on an arcane quality due to colour changes. In many of his pictures he returned to the white ground of earlier painters, putting in his underpainting in bright pastel colours much diluted with turpentine, applying thick or thin paint on top to get his effect. For Turner effect was all, and he employed any technique to get it – scumbling, glazing, palette-knife, scratching, diluting thick paint already on the canvas, and even mixing his colours on the canvas rather than on the palette. Often he laid his pure colours down side by side, and it is no wonder that the Impressionists in France claimed Turner as their own. It is difficult to think of any other artist who has exploited the qualities of oil paints so completely as Turner, and if he

did have a weak point it was his figures.

It was in figure painting that William Etty (1787–1849) was supreme. The nude was Etty's subject and obsession, and he was probably the most 'painterly' specialist artist of the period. Known as the English Titian, Etty was a master of his medium, and in his flesh tints managed to produce a pearly glow so distinctive that it was said that he used a 'secret medium'. Unlike other classically trained painters, Etty employed any technique that occurred to him, taking off glazes with his thumb, dabbing at the paint surface with his pocket handkerchief, and scratching with his thumb nail when it seemed that this was what was wanted. He achieved a pearly glow through tiny specks of black and white.

With the increasing number of art schools and the growing influence of the Royal Academy Schools, there was an emphasis on formula painting, tight control, and no improvising. To escape this formal training, many students went to Paris to study in the studios of the famous French artists of the time, only to find that they too were hard taskmasters, though there was

Above: Walton on the Naze by Ford Madox Brown. The Pre-Raphaelites were famous as colourists and for their attention to detail. This is an excellent example of aerial perspective.

Left: The Dogana, San Giorgio Citella, from the Steps of the Europa by J. M. W. Turner. Because Turner was so preoccupied with light, his brush work had to have a translucent quality. He created his effects by building up thin glazes of oil medium.

The Winnower by Jean-François Millet. His paintings were recognized as being dark and sombre, but nevertheless he still managed to convey a marvellous illusion of light.

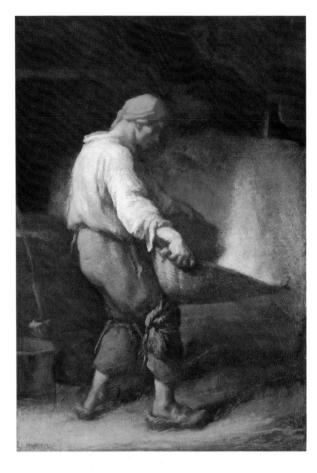

Below: Mariana by John Everett Millais. Millais was completely captivated by detail as this painting aptly illustrates.

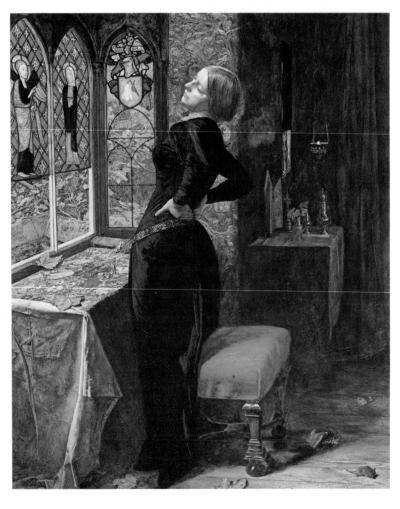

always the odd eccentric.

Typical of the 19th-century French painters was Jean Millet (1814-1875), one of a group known disparagingly as the Dismals on account of their subject matter and not their personalities. Millet's picture The Angelus was probably the most famous painting in the world. Unending toil was the theme of Millet's work, which was subdued in colour (browns, blue/ green, black, white, iron oxide red), and dramatic in lighting. Millet used an off-white priming, and he established his design with charcoal or chalk, using a wash to establish outlines and masses. Shadows were added, leaving the underpainting for the half-tints, and the highlights were added, fairly heavily. The background was often colour-scumbled, letting the underpainting show through, and he strengthened his outlines with a soft brush which, although effective at times, gives his figures the appearance of cut-outs or cartoon characters; not the kind of thing the Paris art schools liked at all. The texture of Millet's paint closely resembles plaster, but his vigorous handling and unconcern for the proprieties had a powerful effect on subsequent painters, such as van Gogh. He also made gloom and the downtrodden peasantry fashionable. The handling of paint, clotted and earthy, is akin to the techniques used by the 'Kitchen Sink' English school of the 1950s and 1960s. There is no doubt that Millet is an important figure and well worth more than a cursory glance. It is the kind of painting which is not too difficult to do and which always makes a dramatic impact on the spectator.

It is a world away from the academically trained British artists of the period, who thrived on patience and perseverance and techniques of a high order, not afraid to spend weeks on some tiny detail and who used brushes with one or two hairs only. The ultimate in this kind of highly-detailed work is Richard Dadd's *Titania*, which became the highest priced British painting of all time in March 1983 at £500,000 (\$1,000,000).

You can still hear modern artists sneering at the Victorian painters, even though their work now regularly commands five and six figure sums in the sale room. This may be due to sour grapes because these modern artists cannot emulate the skill and artistry of Victorian painters. You can fudge a Millet, a Constable, or a van Gogh; you cannot fudge a Lord Leighton, an Alma-Tadema, or a Poynter.

Lord Leighton (1830–1896) was typical of them and his nudes created something of a scandal when they were exhibited at the Royal Academy. Leighton made many thumb-nail sketches before he began, and then laid out his

design on paper, squaring it up for transfer to canvas or, if the design was full-size, using the pricking method. A small oil-sketch was made to establish the colour scheme, and then Leighton put in his underpainting in a warm monochrome. If it was a nude the nude was painted first, and the draperies were added later, from separate studies. Leighton used a flat translucent wash for the draperies so that the modelling of the nude would show through, and he then began to apply the thicker colour, preferring stiff paint with very little medium. He kept the surface 'dead' until the latter stages, when he would add more medium to liven the painting up. His colour scheme, about which he was careful, was ultramarine, yellow, cadmium red, scarlet madder, yellow ochre, burnt sienna, indigo, rose madder, madder carmine, black and white. He and his contemporaries preferred a white priming, as this was what his clients liked, as a reaction against the 'Black Masters' (the old painters whose work could barely be discerned beneath their coatings of heavy varnish and dirt). The sparkling character of much Victorian painting owes everything to precise and well-understood techniques, which are still evident.

The Victorian academic painters based their pictures on good drawings; oil paintings were regarded largely as tinted drawings, and the greatest public acclaim came for those pictures which were as near to reality as possible, and had finish. There was little wilful distortion, except for comic effect: this was left to the cartoonists and caricaturists. Of course there were some painters, such as Rossetti, who had not trained at the art-world establishments, and others who pursued their ways oblivious to public opinion. G. F. Watts was more concerned with the message and not the medium, and his vast allegorical pictures are still out of fashion. When he felt that he had made his point, Watts stopped painting his particular picture, and the rough coarse canvas he preferred was left with blank spaces showing through, so sparse was the paint. He laid on pure colours without mixing on the palette, he ignored detail, and did not like objects to have firm outlines, preferring them to melt into the background.

Our English Coasts by William Holman Hunt. As a Pre-Raphaelite, Hunt was much preoccupied with realism and attention to detail as well as with quality of light, which is evident in all his paintings.

Le déjeuner sur l'herbe à Chailly by Claude Monet. In this sketch, inspired by Manet's picture, and in direct emulation, Monet determined to show how open-air painting should be done. Manet's Déjeuner is obviously of models posed in a studio against a painted backdrop, resulting in a highly artificial picture. Monet worked from sketches and figure studies made on the spot. This sketch for the life-size work shows what Monet intended but never completed.

There were always painters who broke with the establishment, either from inner compulsion to do their own thing or from the awareness that there was no one best way to paint. Edouard Manet (1832-1883) combined traditional and experimental techniques. He was influenced by Velazquez, and wished to reduce half-tone in his pictures and thus stress the contrast between lights and darks. He used offwhite canvases, painted wet-on-wet, mixing his colours on the canvas, and when he had painted his main groups he defined them by going over the outlines with a pointed brush. His main objects he painted with thick rich pigment, but his backgrounds were often scumbled. Sometimes he would scrape down his day's work, leaving the merest vestiges, and evolve anew from these. Although often lumped in with Impressionists such as Monet, Manet was a supreme virtuoso, knowing instinctively when to leave off, and how to suggest texture without being too specific. If you want an English equivalent, there is no more suitable candidate than John Singer Sargent (who as it happens was American).

Why Manet is still described as an Im-

pressionist is something of a mystery; probably because he gets muddled with Claude Monet (1840–1926), a painter preoccupied with catching the fleeting effects of light, and who thus had to work fast and on the spot. He used a weak see-through priming, and blocked in his main features with thin scumbled paint, over which he applied opaque paint very dry, dragging the brush across the underpainting in strokes so that the previous layer showed through. There are very few absolute darks in Monet's paintings, for he usually mixed his colours with white. He was good on shimmering effects, and creating texture through his brushwork, often drawing through the paint with the handle of his brush to reveal the colour beneath. Viewing a Monet painting at close range is a meaningless exercise, for we see only dabs and blotches of colour. Despite the speed at which he worked, Monet was always careful with technique, and despite his mixtures of wet-onwet and wet-on-dry and his indifference to outline, especially in his later work, he managed to avoid muddiness, a constant menace to those who paint in dabs rather than areas of colour.

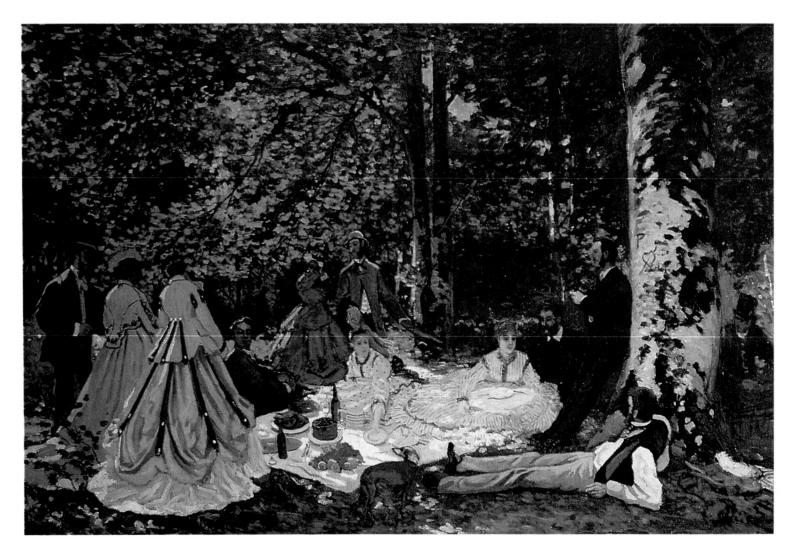

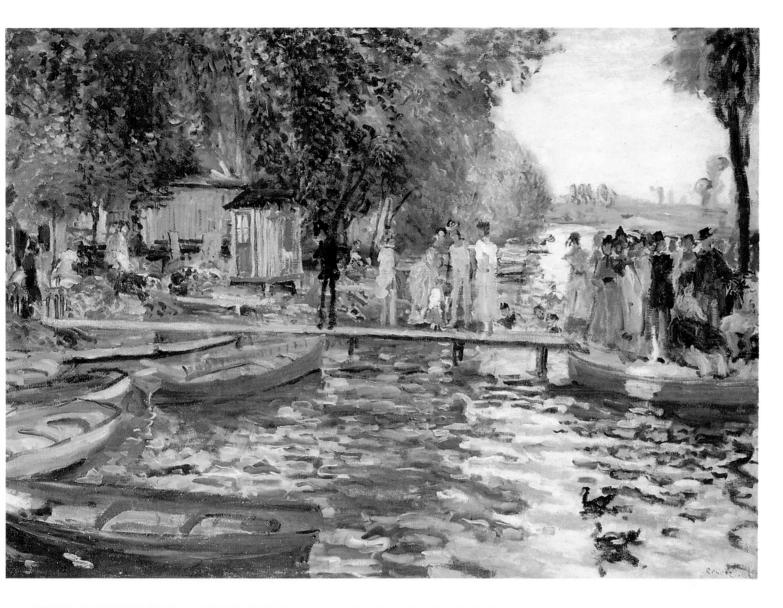

Above: La Grenouillère by Auguste Renoir. Renoir, who had developed a delicate touch as a china decorator, is more fluid than Monet, who is quite rough in his efforts to achieve freedom.

Left: Waterloo Bridge. Cloudy Weather by Claude Monet. The bridge, crowded with traffic, stands dark and brooding over the fast-running Thames. Monet praised the London fog for eliminating details. When the weather changed with spring, he left London.

Above: Georges Seurat's La Bec du Hoc, Grandcamp. This painting is a classic example of the technique of pointillism.

Far right: Vincent van Gogh's Sunflowers is one of the world's best-known paintings. Much of the excitement of van Gogh's painting lay in his eagerness to make the picture as quickly as possible. He virtually attacked the canvas with the utmost urgency and, in some cases, without even bothering to prime the canvas first.

Georges Seurat (1859-1891) became concerned with colour and optical theory, and introduced the 'pointillist' technique, covering the painted areas with tiny dots of different colours, which, in theory, merge in the viewer's eve to become one. He painted wet-over-dry to retain the vivacity of the colours, and in his underpainting, carried out in the local colours of the objects, he outlined the objects with the brush. His object outlines are always immaculately defined, and his areas are never blurred and haphazard. His colour sense was incredibly subtle, which cannot be said of his almost exact contemporary Vincent van Gogh (1853–1890), whose Sunflowers has probably inspired many amateur artists, often with disastrous consequences. Van Gogh used coarse canvases, often painting directly on to them without a priming, and using opaque paint from the start, without any attempt at underpainting. The features of his pictures were worked over and outlined, usually in an unlikely colour such as blue or brown. The texture of van Gogh's paint has something of cream cheese, and to build up his impasto he mixed in wax. There was no attempt at finish, and his vigorous and frenzied brushwork is everywhere evident. In his admirers this type of brushwork becomes scratchy and irritating.

In his way, van Gogh emancipated colour from the restrictions placed on it by reality, and in the beginning of the 20th century a group of painters known as the Fauves ('wild beasts') glorified paint, were not concerned with representation, painted directly, and, like van Gogh, drew lines around their subjects to define them rather than let the paint areas do this job. Characteristic of these painters was Henri Matisse, but it was probably the type of artist personified by Pierre Bonnard (1867-1947) who has had more influence on more recent representational art. Bonnard was not interested in building up solidity or creating an illusion of depth, but aimed at a tapestry effect. He used a fairly absorbent ground, applying thin scumbles of diluted paint which he then intensified with thicker dabs of dryish powdery paint, a subtle form of picture-making.

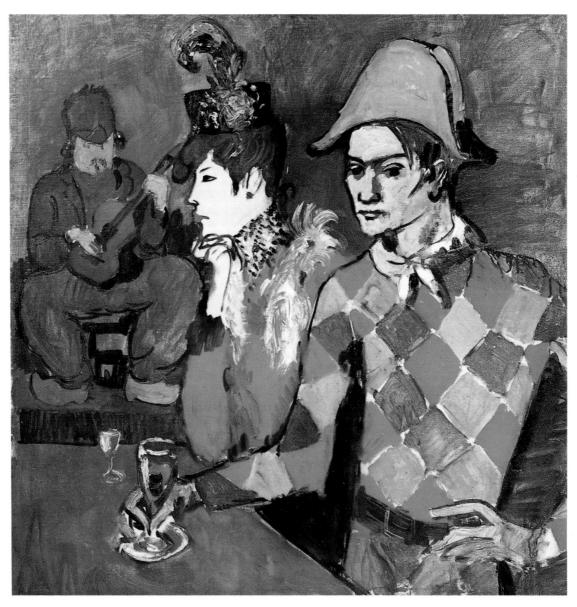

At the Lapin Agile by Picasso. In this picture Picasso uses all his skill of incorporating several different techniques. The figure of the guitarist in the background is just painted in flat washes. The woman (middle foreground) in the style of Toulouse-Lautrec is painted with no paint at all on her face and only the suggestion of a Prussian blue outline to suggest her features The harlequin in the foreground has been tonally painted over a dark base and the highlight is suggested by a thick body colour on the face.

We have the paradox of artists using conventional means to paint unconventional pictures (even early Picasso of the Cubist period fits into this category) and others using unconventional means to paint conventional pictures. A splendid example is the Newlyn School of Cornwall, which flourished from about 1885. Their techniques, especially those of the key artist Stanhope Forbes, would not seem at all outrageous today - indeed, their methods were wholeheartedly taken up by art colleges in later years. The Newlyn painters were very keen on outdoor painting - 'Your work cannot really be good unless you have caught a cold doing it' one of the artists commented wryly - but this had nothing to do with the technique they began to use, which the critics thought was derived from France.

This was the use of flat square soft brushes, a technique that was ridiculed by the critics in the late 1880s, though it had been used for well over a decade, especially by Stanhope Forbes (1857–1947). These painters of the 'Square Brush School' concentrated on tone, outlines were blurred, and the evocation of atmosphere was encouraged. The strokes were crisscrossed and hatched. An excellent description of the difference between standard technique and square brush was written by a critic in 1893:

'The technique of the Newlyner is often thus roughly described: the ordinary, everyday artist, if he wants to paint a ship's mast against the sky, takes a brush, coming to a fine point, and draws it vertically up and down his canvas in the place desired. The Newlyner does nothing of the sort. He uses a squarer brush and gets his mast by series of horizontal strokes.'

Stanhope Forbes gradually gave up his concern with tone rather than colour from about 1910 when he was elected a Royal Academician. The square brush style of painting certainly did not exclude detail, though the more modern practitioners of the method took the same delight in

The Chimneypiece by Edouard Vuillard. Composition is quite often the main feature of a painting. In this picture the artist has used a massive stone fireplace which enhances the delicate treatment of the still life. This picture is extremely pleasing and decorative.

tone rather than colour, as we can see in the 'descendants' of the Newlyn School, the Euston Road School, the London Group, and the Camden Town School – and, sometimes incongruously, in contemporary painters who happened to be at art school when this technique was being most arduously advocated.

With the breakdown of traditional art teaching, the way has been left open to the most fantastic of methods, some good, some not so good. The seeds of anarchy were sewn (for good rather than for ill, as Edwardian painting was getting stale) in the first two decades of this century, when the artist began to explore all the possibilities, introducing into his paintings elements from outside, such as sticking on bits (collage). At its most extreme, collage could incorporate vegetable matter, as with Jean Dubuffet's work; in the 1960s I saw one of his pictures begin to disintegrate in the hot atmosphere of an exhibition gallery. If modern art has done nothing other than encourage timid amateurs to have a go, it has provided a

Modern art is popularly supposed to be progressive or futuristic, but of course this is not necessarily so, nor are the most inventive of contemporary painters less careful in their techniques than the artists of previous centuries. Naturally the more outrageous artists get the attention of the media, but a lot of noise and publicity does not mean that they are any good,

and will not be forgotten in 20 years time. Many of the so-called pathfinders to a new art have disappeared entirely from view.

Of the 20th-century artists about whose credentials there is no doubt, Paul Klee stands out. He also explained his techniques with extreme lucidity in *Paul Klee on Modern Art* (1948). He wrote about how he started a picture by doodling, by playing with lines and colours until they suggested some association or title; he mentions 'lines going for a walk'.

Left: Detail of They're Biting by Paul Klee. Although on analysis Klee's methods and techniques were quite sophisticated, there was a good deal of simple fun and humour in his painting.

Right: A Young Lady's Adventure by Paul Klee.

Sometimes a title preceded the actual work; usually it was an enigmatic or fairy-tale title, a label that often had little to connect it with the actual picture. It is often difficult to say which is playing the greater part in Klee's work, the conscious or the unconscious. Except in his later paintings when he was inclined to be turgid, the bulk of his work is enchanting, small-scaled, and rich in detail and texture – and without modelling of any kind.

In The Refugee, Klee used six distinct media and as many as 10 layers. Working on cardboard, he first of all applied a priming of white, then reinforced the surface with gauze, glue and gesso. He then did an underpainting in brown watercolour, and put in his design with tempera, refining this with detailed drawing and watercolour hatching. Next, he put on a coat of thin varnish, and then heightened certain details with white oil paint. He then put on a glaze of blue-grey oil colour, and when this had dried finished off the painting with a glaze of madder lake. Sometimes he built up his paintings like mosaics, with hundreds of tiny squares of contrasting colour. Klee was one of the least brash of 20th-century artists; Roy Lichtenstein, the American pop artist, was probably one of the most.

It is interesting to compare the way Klee and Lichtenstein dealt with their surface textures, in particular their dots of paint. Klee's dots were applied individually; Lichtenstein, with the aim of getting the look of a comic or of a half-tone reproduction in a newspaper, used a metal mesh screen, which was placed on the canvas. Paint was brushed through the circular holes, and the screen was lifted off.

While pop art unquestionably has its niche,

irritating as it may be to those not turned on by comic strips or Marilyn Monroe, many of the better artists of today have returned to representation, and some of them, such as Peter Blake, have very assured techniques that equal those of the best Victorian artists. In his more recent work, David Hockney paints with the care and precision, the preparation and attention to detail, that were expected of the masters of the past, using traditional techniques in acrylic.

Below: Whaam! by Roy Lichtenstein. This artist was inspired by modern graphics.

David Hockney's Mr. and Mrs. Ossie Clark and Percy. A masterful modern painting which uses light and shade to the utmost dramatic effect.

However, this is not an art history or a paean to selected artists. Can we learn from these techniques? Although many of us are too impatient to apply glaze after slow-drying glaze over a carefully designed underpainting, we can short-circuit the oil-painting process by using acrylic, in which five successive glazes will dry in a couple of hours. One of the virtues of the use of transparent glazes is that the picture comes along bit by bit, underpinned by the underpainting so that the artist who has some idea of the end product cannot come wholly to grief. Painting direct *can* be a hit-or-miss method, though it is unquestionably the method most practised today.

For those who wish to simplify their forms, or are more concerned with colour than with tone or reality, there is a lot to be said for the blackline method (outlining the objects in a picture, or some of the primary objects in a picture, with the point of a soft brush). At its most subtle, this method can be seen in the work of Matisse; at its most majestic and sombre in the work of Georges Rouault. Rouault painted in several layers, altering and amending, outlining his paint areas with thick black lines.

A modern art historian perceptively drew an analogy between Rouault's paintings and stained glass windows.

The black-line method need not be forceful

and attention-grabbing, but merely a faint line separating the various patches of colour, a process used for centuries, particularly in water-colour painting. There is no question that there are more technical variations possible in oil painting than in watercolours.

Below: The Inattentive Reader by Henri Matisse. In this painting, the artist appears totally preoccupied with the poetry of flat colours.

Jean-François Millet used a five-colour palette. Titian managed most successfully with nine, compared with Rubens who used thirteen.

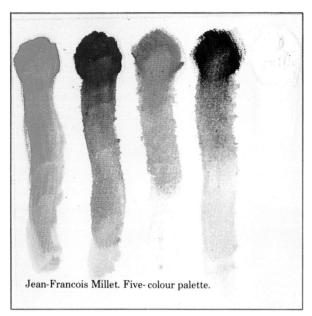

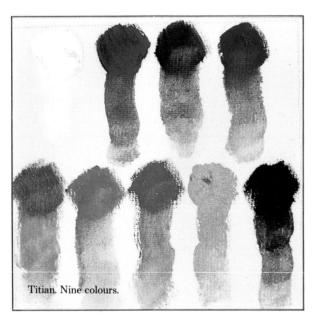

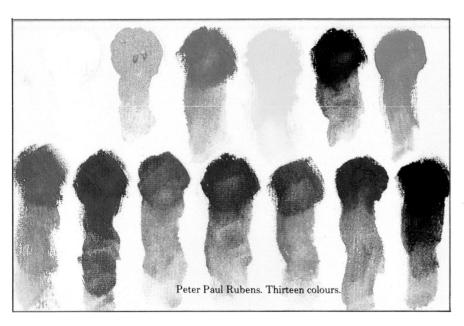

Colour Schemes

Each painter has favourite colours and combinations of colours, and sometimes these are so personal to the artist that you can pick him out not by his style or subject matter but by the general colour scheme.

Many artists used a very limited range of colours. Jean Millet (1814–1875), whose painting *The Angelus* was once one of the half-dozen most famous paintings in the world, often used a palette of no more than five colours: iron oxide red or vermilion; a brown earth colour of the burnt sienna variety; a blue green; a black; and white.

A modern artist who imposed a similar restraint on his palette was L. S. Lowry. He said: 'I am a simple man, and I use simple materials: ivory black; vermilion; prussian blue; yellow ochre; flake white – and no medium. That's all I've ever used for my painting.'

The writer on art A. W. Rich advises a palette of five colours: light red; yellow ochre; cyanine blue; ivory black; burnt sienna. As a concession, the same authority allows five more colours: viridian; raw sienna; ultramarine; aureolin; rose madder. The great drawback of this palette is that it lacks a vivid red.

Many of the great artists used a very wide range of colours, though Titian maintained that a painter needed only three. Nevertheless, he used nine colours: lead white; ultramarine; madder lake; burnt sienna; malachite green; yellow ochre; red ochre; orpiment (literally translated as 'gold paint'); ivory black.

Van Eyck had a palette of eight colours: brown; madder; ultramarine; yellow ochre; terre verte (a green); orpiment; red ochre; peach black.

Rubens used many: lead white; orpiment; yellow ochre; yellow lake; madder; vermilion; red ochre; ultramarine; cobalt blue; terre verte; malachite green; burnt sienna; ivory black.

The writer on art Hilaire Hiler, whose *The Painter's Pocket Book* (1937) is the best book of its kind ever written, gives a choice of two palettes, one low-toned, the other high-toned. The low one was: titanium white; yellow ochre; light red; cobalt blue; ultramarine. The high-toned one was: titanium white; cadmium yellow; ultramarine; cadmium red; lamp black.

In 1876 the aesthete P. G. Hamerton (1834–1894) declared what he thought was a basic essential palette. Hamerton was an artist of a kind, but is best known as a moderately influential critic of the middle-of-the-road school. These are the colours a good Victorian would have used: flake white; pale cadmium yellow; vermilion; rose madder; ultramarine; emerald green; vandyke brown; black.

It is interesting to compare this palette with

that of the great Impressionist artist Renoir (1841–1919) at the same time: flake white; Naples yellow; chrome yellow; cobalt or ultramarine; alizarin red; viridian; emerald green; vermilion. Notice that Renoir did not use blacks at this time.

Renoir's palette was not so different from that of Georges Seurat (1859–1891), who evolved the 'pointillist' technique, in which separate dots of primary colours such as blue and yellow were placed side by side and intended to be interpreted by the human eye as green: white; an orange; raw sienna; alizarin red; ultramarine; cobalt blue and perhaps cerulean blue; vermilion; emerald green; viridian; cadmium yellow; yellow ochre.

Vincent van Gogh also eschewed the use of black: lead white; red lake; vermilion; cadmium yellow; ultramarine; cobalt blue; cobalt violet; emerald green; viridian; an earth colour probably sienna, burnt or raw.

A palette suitable for acrylic painting could

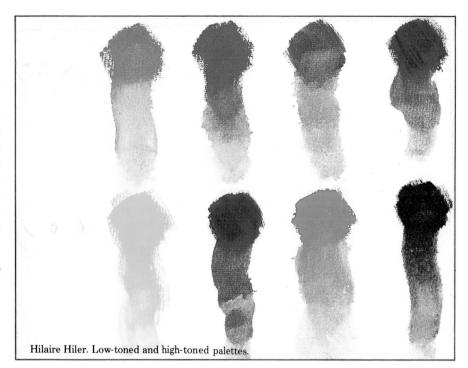

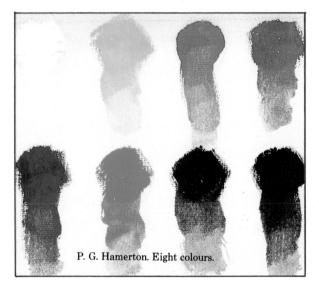

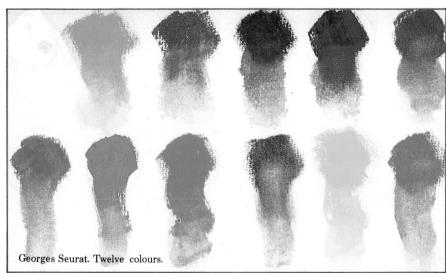

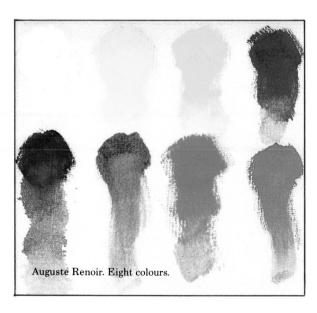

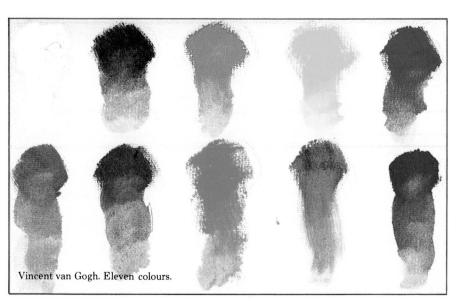

be made up of the following: a green; burnt and raw umber; cadmium yellow; cadmium red; crimson; raw sienna; ultramarine; cobalt blue; black; white.

Most of the palettes listed are general purpose ranges, but if you have in mind a green-based colour scheme you could restrict your choice to: black; white; burnt sienna; burnt umber; cadmium red; cadmium yellow; cobalt blue; chrome green; yellow ochre. Red mixed into a green is an admirable 'cooling down' colour. The chief fault of novice land-scapists is to make the greens far too green and brash.

A rather cold colour scheme is: black; white; alizarin crimson; cadmium yellow; chrome green; monastral blue; violet.

A hot somewhat acid scheme is: black; white; burnt sienna; cadmium green; cadmium lemon; cadmium orange; cadmium red; cadmium yellow; cobalt blue; ultramarine; viridian; yellow ochre.

An interesting palette evolved by a pre-war chemist named Toch guaranteed permanency of pigments: Venetian or light red; medium cadmium; ultramarine; lamp black; zinc white; raw sienna; burnt umber; chromium oxide (yellow); madder lake.

These selections are only a handful of the hundreds of different schemes used by artists, and everyone will want to create their own. Some of the pigments used by the great painters of the past are not available at artshops, perhaps fortunately, for many of the masterpieces we take so much for granted have been repainted so many times that they can hardly be called original works of art, since they have been repainted because the colour has literally disappeared or been transmuted. In Antwerp Museum there is a trunk containing the powdered colours used by Rubens (putting colour into tubes is fairly recent, dating back to the 1840s). The ultramarine, the madders, the lead white and all those browny colours known as earth colours have survived well, but the yellow lake, the vegetable greens and vermilion have almost entirely faded away. The ultramarine of the old painters was originally made from lapis lazuli, but even before the Second World War it cost more than a pound sterling for a tiny pan and is now virtually priceless. The modern equivalent is French ultramarine, the principal ingredients of which are sulphur and sodium.

Scientists have discovered (or decided) that there are 80,000 tints between white and black. Within a range of 20 colours or so most of us can get what we want.

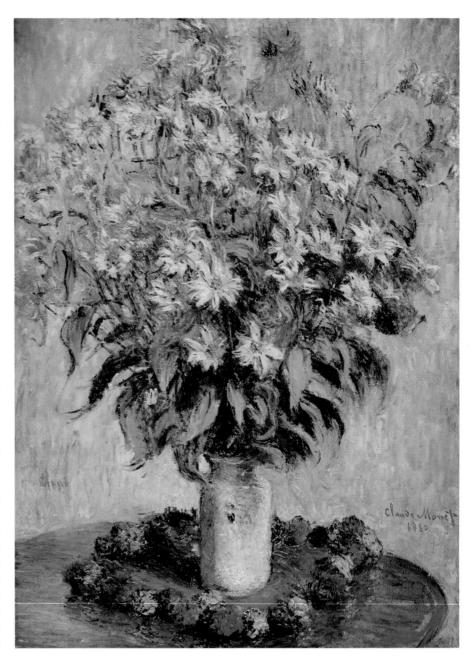

FRAMING

Oil paintings are usually framed without glass, though if you wish they can be mounted and placed under glass, in the same way as water-colours, if they are painted on board, canvas paper, or card. If on canvas this is not possible. The mouldings of frames vary enormously; some are plain and some are intricate, and if you have no preferences a picture-framer is always the best person to advise.

Framing kits are readily available at reasonable prices, and it is always possible to find old frames, in second-hand shops and junk shops and at open markets, which may merely need a good clean up. In the old days frames for oil paintings were gilt and ornate, and often the mouldings of these were made of gesso, a mixture of plaster of Paris and glue which was subject to damp and time. If suitable frames are bought with peeling or damaged gesso it is better to strip the whole lot off to the bare frame, which can be gilded, painted, or waxed

and polished. All second-hand frames should be freed of any backing paper, and all nails should be removed, as well as hanging cord, whether wire or cord.

If the moulding of the frame is in good condition, and if the design is 'built out' on wires coated with gesso, there is a chance that the frame may be worth a good deal of money. If the frame is carved, and if it is intricately carved with vine leaves, fruit, or other decorative devices, it could be worth not just a good deal of money but a fortune, so before you put your own picture in such a frame get expert advice. One wealthy collector who buys such frames, which are usually antique, displays them on the wall – by themselves, without a picture.

Oil paintings on card, board, or canvas paper can be cut down to fit an existing frame, but a painting on a stretched canvas must have the right size frame, though there can be a little leeway of a centimetre or so which can be wedged. Unless you are a skilled woodworker, do not try to cut frames down, as the merest error shows when the frame is reassembled.

Far left: Claude Monet's Vase of Chrysanthemums. Between 1878 and 1882 Monet painted some twenty still-life and flower paintings. Chrysanthemums were very much part of the vogue for things Japanese in Paris, and were a symbol of luxury and exoticism in the works of poets and novelists.

Left: A variety of frame designs suitable for oil paintings.

Far left below: Claude Monet's Tulip Fields at Sassenheim. When Monet revisited earlier haunts he seemed to revert partly to earlier styles: particular places, for Monet, called for a particular painting response.